15679

REMBRANDT SELF-PORTRAITS

CHRISTOPHER WRIGHT

Rembrandt: Self-Portraits

A STUDIO BOOK

THE VIKING PRESS

NEW YORK

First published in 1982 by The Viking Press (A Studio Book)
625 Madison Avenue, New York, N.Y. 10022
Published simultaneously in Canada by
Penguin Books Canada Limited

First published in Great Britain by Gordon Fraser Gallery Ltd
London and Bedford

LIBRARY OF CONGRESS CATALOGING IN PUBLICATION DATA
Wright, Christopher, 1945–
 Rembrandt self-portraits.
 (A Studio book)
 Bibliography: p.
 Includes index.
 1. Rembrandt Harmenszoon van Rijn, 1606-1669—
Self-portraits. I. Title.
N6953.R4W7 760'.092'4 82-70176
ISBN 0-670-59356-7 AACR2

Set in Monotype Baskerville
and printed at The Roundwood Press, Kineton, Warwick
Colour origination by Adroit Photo Litho Ltd, Birmingham
Paper supplied by Frank Grunfeld Ltd
Bound by Pitman Press, Bath
Designed by Peter Guy

FOR MY MOTHER

AND IN MEMORY OF MY FATHER

CONTENTS

PREFACE

THIS BOOK brings together the obvious – the most extensive sequence of self-portraits in the whole history of Western painting. The most plausible reason for the rarity of this inclusionist approach is simply that most writers on Rembrandt choose only those pictures which please them and then arrange their choice to fit a very personal point of view. The approach taken here is in strong reaction to this often misleading selectivity. All the artist's surviving pictures are discussed, even if they do not appear to fit into the accepted view of Rembrandt and even when the author is forced to stark conclusions by the evidence before him. Rembrandt tells us far less than we would like to know about himself, even when we look at his whole output. Instead he has given every generation great freedom of interpretation, a freedom often abused.

In collecting material for this book I have used the Witt Library at the Courtauld Institute of Art and the Rijksbureau voor Kunsthistorische Documentatie at The Hague, where Willem L. van de Watering answered my constant questions with tact and care. Several people have kindly loaned me books and articles and I am especially grateful to Dr Albert Blankert and Alan Jacobs. Julius Szakaly and Anne Hunter helped in various ways and Gary Schwartz saved me from a serious omission at the last minute. Diana de Marly kindly warned me of the many problems which surrounded Rembrandt's use of sixteenth-century costume in his portraits and Caroline Pilkington (with the assistance of Miss Sykes) was a patient typist whose sharp eye found several inconsistencies. Robert Oresko encouraged the project in its early stages. I am grateful to Simon Kingston and Peter Guy who saw the book through the press and gave much needed encouragement.

ACKNOWLEDGEMENTS

Stedelijk Museum 'De Lakenhal', Leiden, and the Dienst Verspreide Rijkscollecties, The Hague, fig. 1.
Rijksmuseum, Amsterdam, figs 2, 3, 8; plates 11, 13, 94.
Private Collectors, figs 3, 5; plates 15, 38.
Bernard Solomon Collection, Los Angeles, fig. 4.
City Art Gallery and Museum, Glasgow, figs 6, 23.
National Gallery, London, figs 7, 12; plates 65, 96.
Rembrandthuis, Amsterdam, fig. 8; plate 75.
Alte Pinakothek, Munich, figs 9, 10; plate 8.
Mauritshuis, The Hague, fig. 11; plates 14, 49, 97.
Henschelverlag, Berlin, fig. 13; plate 51.
Stadtmuseum, Weimar, fig. 13.
Akademie der bildenden Künste, Vienna, fig 14.
Museum Boymans – van Beuningen, fig. 15, plate 86 (Koenigs Collection).
Museum der bildenden Künste, Leipzig, fig. 16.
Rousham House, Oxfordshire (collection of C. Cotterell-Dormer), fig. 17.
Staatsgalerie, Stuttgart, fig. 19.
Clowes Collection, Indianapolis, fig. 20; plate 12.
Frans Hals Museum, Haarlem, fig. 21.
Museum of Fine Arts (Zoë Oliver Sherman Collection), Boston, fig. 22.
Holburne of Menstrie Museum, Bath, fig. 24.
Musée des Beaux Arts, Besançon, fig. 25.
J de Bruijn Collection, Muri-Berne, plate 6.
British Museum, London, plates 7, 36.
Musée du Louvre, Paris, plates 24, 44, 45, 56, 89.
Musée des Beaux-Arts, Marseilles, plate 43.
Kupferstichkabinett, Berlin, plate 53.
Metropolitan Museum of Art, New York, plates 54 (Robert Lehman Collection), 18 (bequest of Evander B. Schley), 90 (bequest of Benjamin Altman).
National Gallery, Washington, plate 62 (Lessing J. Rosenwald Collection).
Albertina, Vienna, plate 85.
Staatliche Gemäldegalerie, Kassel, plates 10, 50, 77.
Fogg Art Museum, Cambridge, Mass., plates 16 (James P. Warburg bequest), 93.

Cramer, The Hague, plate 17.
Nationalmuseum, Stockholm, plate 19.
Isabella Stewart Gardner Museum, Boston, Mass., plate 20.
Walker Art Gallery, Liverpool, plate 21.
Galleria degli Uffizi, Florence, plates 22, 79, 95.
Musée du Petit Palais, Paris, plate 37.
Bulloz, Paris, plate 37.
Philips Collection, Eindhoven, plate 39.
Burrell Collection, Glasgow, plate 40.
Staatliche Gemäldegalerie, Berlin – Dahlem, plates 46, 52.
Collection of the Prince of Liechtenstein, Vaduz, plate 51.
Wallace Collection, London, plate 57.
Museu de Arte, Sao Paulo, plate 58.
Staatliche Gemäldegalerie, Dresden, plates 59, 63, 80.
Norton Simon Foundation, Pasadena, Calif., plate 64.
Collection of the Marquess of Tavistock, Woburn Abbey, Bedfordshire, plate 66.
National Gallery of Canada, Ottawa, plate 67.
Baron Thyssen Collection, Lugano, plate 68.
Her Majesty The Queen (Royal Collection, Windsor Castle), plate 69.
Staatliche Kunsthalle, Karlsruhe, plate 72.
National Gallery of Art, Washington (Widener Collection), plates 73, 88.
Kunsthistorisches Museum, Vienna, plates 76, 78, 83.
M. H. de Young Memorial Museum (The Roscoe and Margaret Oakes Foundation), San Francisco, plate 81.
National Gallery of Scotland (and the Earl of Ellesmere), plate 82.
Musée Granet, Aix-en-Provence, plate 84.
Frick Collection, New York, plate 87.
Iveagh Bequest, Kenwood House, London, plate 91.
National Gallery of Victoria, Melbourne (Felton bequest), plate 92.
Wallraf-Richartz Museum, Cologne, plate 98.

INTRODUCTION

REMBRANDT is one of the few painters who have a universal appeal. His art has been respected for three centuries. Most people feel themselves to be quite familiar with him; they can follow each stage in his troubled life and can be moved by his tremendous powers of expression. By contrast, the examination of documents and the deliberations over authenticity can appear to be an insult to this intuitive genius, most of whose work is demonstrably unlike that of his contemporaries. For an understanding of Rembrandt's art the historian may seem largely superfluous. The painter exists in everybody's mind by direct experience. In front of *The Night Watch* or *The Jewish Bride* words are hardly sufficient. Eloquence is no substitute for looking at the work of art itself.

Rembrandt's art is so diverse that even the briefest study of it becomes impossibly long. The subdivision of any creative entity is bound to be artificial, and artists' pictures have very rarely been kept together as they usually left the studio upon completion. The painter could not therefore refer back to his own work, unable to share the ease with which we can turn the pages of a book. It is improbable that Rembrandt kept his self-portraits in his studio because some of them at least would have been recorded in the enormous inventory of all his effects drawn up at the time of his insolvency in 1656.

Probably fifty self-portrait paintings survive, although some scholars, especially Bredius and Hofstede de Groot, preferred to accept over sixty. In addition there are several pictures which are portraits of Rembrandt by other painters (see figs. 3-8, 12 and 16). These alone amount to more portraits than of any other contemporary artist. So convincing are Rembrandt's self-portraits that we feel we can arrive at an easy familiarity with the man, backed up by a certain amount of biographical data and information on his main commissions.

For Dutch seventeenth-century art as a whole there is a curious lack of documentation. The straightforward history of Rembrandt's career is difficult to chart properly as the documents are so scanty. It is the historian's duty to sift the evidence as best he can in the hope that the results will lead to a fuller understanding of the circumstances in which Rembrandt created so much of his moving work. In the instance of his self-portraits the result is the abandonment of a good deal of wishful thinking and its replacement by a very few certainties.

This current feeling of unease is reflected in the fact that almost all the recent literature on Rembrandt has had a heavy bias towards questions of authenticity. But the point which has been avoided by most authorities is a very obvious one; how did the Rembrandt corpus as we now know it come to be constructed in the first place? Rembrandt died rather more than three hundred years ago but the first book on him did not appear until 1836. The intervening years saw slowly increasing appreciation of his pictures after the comparative neglect into which they had fallen just after the artist's death. In the eighteenth century, pictures tended to be appreciated for their mood or

subject matter and connoisseurs did not on the whole emphasize the importance of authenticity.

The amount of information which survives concerning Rembrandt's career as a whole is well above the average for a seventeenth-century Dutch painter. It therefore comes as a shock that the self-portraits mentioned in the artist's lifetime are exactly two in number (see p. 129) and neither of them can be certainly identified today. For instance it is known that Charles I of England owned a self-portrait by Rembrandt because it is described in the inventory of the king's possessions drawn up in 1639. But after the picture's sale by the Commonwealth authorities in 1651 all trace of it was lost. In recent years the Walker Art Gallery at Liverpool acquired a *Self-portrait* (Plate 21) answering the description of 1639 and at least it can act as a guide to the type of painting which was in the king's collection, even if there is no conclusive proof that it is the very picture he owned.

A much more disconcerting gap in the documentation is the absence of self-portraits in the 1656 inventory, although a self-portrait did in fact appear in an Amsterdam sale in the following year. The historian is therefore given little or no help by the documentation. All the memorable images which fill the pages of this book went unrecorded in their time, nor were they mentioned in later years by the few people who wrote about art; such writers were far more concerned about ideas of beauty than with specific pictures. A few self-portraits passed through the Amsterdam salerooms in the last years of the seventeenth century and two self-portraits were noted by Baldinucci in 1686 as forming part of the Medici collection in Florence of artists' self-portraits. One of them is now considered to be a copy by some authorities (see Plate 79).

In the eighteenth century a change came over people's attitudes to pictures in general. Those familiar with the present-day art market are either interested or confused, depending on their viewpoint, by the constant movement of works of art, their sale and resale, their repeated restoration and their unreasoned changes of attribution. This has been the tradition in art-dealing from the eighteenth century onwards when the enormous output of the Dutch seventeenth-century painters formed the basis for this commerce. The only real difference between then and now is that then there was far less concern in the documentation of the movements of pictures which means that it is now rarely possible to trace the history of any given picture in the eighteenth century. Rembrandt's self-portraits are no exception to this pattern. Many of his pictures, without their previous history being recorded, found their way into the collections of German princes and electors who were at that time expanding their picture galleries. Many of these collections remain more or less intact, as at Dresden, Kassel or Karlsruhe, to name three which contain self-portraits by Rembrandt. Even these pictures were acquired on the art-market and not from other distinguished collections.

It is from these saleroom records, or from inventories of grand collections, that some idea can be gained of which types of pictures were the most esteemed. Rembrandt's name appears often enough to show that he was appreciated, and his pictures painted in Amsterdam in the 1630s were much sought-after. The Leiden period in general was neglected as lacking in refinement, while the last pictures appeared un-

finished to eighteenth-century taste. A few of the late self-portraits appeared in the last years of the century (Plates 77 and 95) but they did not fetch high prices, nor were they mentioned by writers.

There was a considerable change of attitude in the nineteenth century which coincided with the sudden importance of critics. The best evidence of this is the work of that indefatigable compiler John Smith, an art-dealer, who drew up lists of an enormous number of Dutch, Flemish and French pictures. His purpose was to safeguard the unwary against the purchase of spurious works of art. In the case of Rembrandt he was remarkably thorough. Almost all the self-portraits known today which were unfamiliar to Smith were from the Leiden period and his comments show a new awareness of the merits of Rembrandt's late pictures.

After Smith's time the number of pictures attaching themselves to Rembrandt's name continued to grow, arriving at impossible proportions by the end of the nineteenth-century. By about 1900 a vast quantity of pictures, probably almost a thousand in number, scattered all over the western hemisphere, were labelled Rembrandt. The self-portraits did not escape this unfortunate trend.

It has been left for present-day students of Rembrandt to realise that the number of pictures seriously attributed to him cannot possibly have been painted by one man; but the process of pruning has often been arbitrary and unjust. Modern scholarship has achieved the reconstruction of the Leiden period but the sad fact remains that questions of authenticity still outweigh all others and that owners, both public and private, of paintings by Rembrandt wait in trepidation for another scholarly demotion of their pictures. A balanced view is therefore difficult at the present time. There can be no recourse to history because of the lack of documentation. Intuition can successfully associate like with like, and it is the connoisseur's most valuable asset, but it becomes pure alchemy then to attach the names of painters to these associations of anonymous pictures.

The only way out of the impasse is to record as carefully as possible all that has been said in the past. The judgement of eighteenth-century connoisseurs in matters of authenticity is often sounder than our own because it was made nearer to the painter's lifetime. They were less likely to make mistakes about the recently dead, in the same way that today the art of the early twentieth century is easier to authenticate than that of earlier generations. Significantly, the groups of Rembrandt self-portraits in collections formed in the eighteenth century such as The Louvre, Kassel, Dresden, have tended to stand up far better to modern critical opinion than the later assemblages of Rembrandt's pictures such as those in the National Galleries of London and Washington.

Critical opinion in the past was largely based on sentiment, but all of it had to be inspired by looking at the picture itself. Today most art-criticism is done from reproductions and reflects that fact. The importance of Fromentin's comments, for instance, lies in the fact that they reveal the man's responses to the picture in front of him and are not notions derived from reading other people's opinions of works of art. This type of criticism is oblivious of problems of authenticity and directly concerned with the subjective appreciation of quality.

Criticism has tended to weave the artist's biography round the favourite pictures. This is especially tempting with the numerous self-portraits. It is possible to put them in a rough order according to the apparent age of the sitter. When this order is then compared to the dates surviving on a good number of them this approach is confirmed. Most of the difficulties arise with the assessment of style which has frequently been proved wrong as a basis for dating the pictures.

That Rembrandt analysed himself in a way unique in the whole history of art has been accepted for several generations, but many misconceptions grew up in the nineteenth century and they are still with us. If all the self-portraits could be spirited into a *musée imaginaire* and put into the appropriate chronological order the result would wipe away the romantic vision for ever. Rembrandt's ability to analyse his own character would be seen to have been present right through his life; it is only the style of the painting which changes and not the power to penetrate. He is as candid about his adolescence (Plate 17) as he is about the final dissolution of old age (Plates 96 and 97). This leads on to the grave misconception that it is possible to work out the artist's biography by looking at the self-portraits. The fallacy is to see the artist's problems in his face before they actually happened. There is the constant tendency to see the artist's difficulties, but never his triumphs, in his ageing face. Pages could be filled, rather like a drama, with portentous tragedy. Rembrandt could then appear as a kind of King Lear among painters as each disaster etched lines deeper into his face.

The analysis of Rembrandt's individual self-portraits which follows tries to include all the pictures which have any artistic quality, and some which do not, chiefly because they are of Rembrandt by other painters. It is dangerously easy for the writer to ignore anything he does not like. Bredius refused to discuss Rembrandt's *Mill* in Washington in this way. The approach taken here therefore has been to point out problematic pictures, particularly if they have been esteemed in the past, in order to reinforce the premise that the art of the past is a collection of attitudes held by the present. It is not a precise event which can be neatly charted. Likes and dislikes have to prevail on all levels of appreciation because history has failed to reveal the facts, and also because Rembrandt's pictures, above all others of his time, are emotional in content and demand reaction on a personal level.

17

96

97

The Leiden years: 1606 – 1631

Rembrandt's career divides naturally into two main sections, the Leiden period, with a short interlude in Amsterdam under Pieter Lastman, and the long main part of his life in Amsterdam. A surprisingly large proportion of his self-portraits date from his former period, especially when the etchings are taken into account. There is no evidence that the young painter had a large market for self-portraits.

Rembrandt's very first steps as a painter have now been uncovered and the pattern which has emerged is quite unexpected. His recently discovered *Baptism of the Eunuch* of 1626 in the Rijksmuseum 'Het Catharijneconvent', Utrecht, is painfully awkward in terms of drawing but quite dazzling in colour. This brilliance of colour favoured by the

youthful painter is also seen in the *Stoning of Stephen* of 1625 in the Musée des Beaux-Arts at Lyons and is generally thought to have been derived from Pieter Lastman rather than being Rembrandt's personal contribution.

The artist's first leanings towards self-preoccupation appear in these early subject pictures. He included himself in the much disputed *Historical Scene* in the Stedelijk Museum 'De Lakenhal' at Leiden. The composition is still gauche, almost childlike, and the colours are bright. Behind the supposed figure of Agammemnon, partly obscured by the potentate's sceptre, is the head of a youth which appears to be that of Rembrandt himself, with tousled hair and a blank stare. The head is quite similar to the drawing in the British Museum which is more usually compared to the *Self-portrait* (Plate 14) in the Mauritshuis, The Hague, perhaps because of the dramatic lighting common to both. The Leiden picture shows that Rembrandt had mastered the popular style of the time, bright colour and obscure or classical subject-matter. He returned to Leiden from Amsterdam after his year in Lastman's studio in 1625 when he was still only nineteen.

The sudden move towards intense shadows in his art can be seen in the small *Musical Company* of 1626 recently acquired by the Rijksmuseum, Amsterdam. It could well be that Rembrandt also included himself in the background of this picture too as the figure playing the harp, although the identification is not conclusive.

fig. 1 REMBRANDT
Historical Scene: Palamedes before Agammemnon (?) (detail)
Leiden, Stedelijk Museum 'De Lakenhal' (on loan from the Dienst Verspreide Rijkscollecties, The Hague).
Oil on panel 89.8 x 121 cm. Indistinctly signed and dated: RL 1626.
This picture has been subject to many different identifications, for example *The Justice of Brutus* and *Cerialis pardons the Roman Soldiers who had sided with the Batavians.*

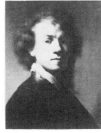

14

fig. 2 REMBRANDT
Musical Company (detail)
Amsterdam, Rijksmuseum. Oil on panel
63 x 48 cm. Signed and dated lower left:
RHL 1626.

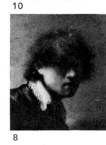

10

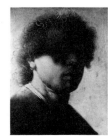

8

The earliest *Self-portrait* proper (Plate 10) is generally thought to be the small panel at Kassel. Already the artist's approach is quite different from those brightly coloured subject pictures. Around the age of twenty Rembrandt had begun the process of self-observation which was to last for over forty years. The Kassel picture is obviously the work of a youth. The paint is laid on rather clumsily and the effect of light and shade on the hair has been achieved by the method of scratching in the wet paint with the end of the brush or another pointed instrument. The lighting used is clever almost to the point of brilliance. The painter has put his face in three-quarter shadow, which allowed him the full range of subtlety with the half tones. The Rijksmuseum in Amsterdam has acquired a similar but rather more sombre version of the Kassel picture, which has every appearance of being authentic. The handling of the shadows is especially subtle. However, the Kassel picture was probably executed shortly before 1629, in which year Rembrandt painted a rather similar picture which is in the Alte Pinakothek at Munich (Plate 8). There are some differences between the two pictures but not in the lighting which is almost identical. The Munich picture is the

more skilful of the two. Rembrandt was still only twenty-three and he was already learning how to handle paint with such confidence that he was able to gain easy success as a society portrait painter in Amsterdam after his move there in 1632.

Even though modern research has been so extensive there are still many unsolved problems for the Leiden years. The reason is easy to find. Rembrandt was a young man with some local but no national success. He was sharing a studio with another young and promising painter, Jan Lievens, whose later reputation is official circles was to be greater than that of Rembrandt himself. It is even possible that the two painters worked on each other's pictures and they were constantly experimenting with new styles. Self-portraiture must have been a great preoccupation at this time as approximately one-third of the paintings and more than half of the etchings date from the Leiden period up to the end of 1631 (Plates 1-38). Not surprisingly many of them are disputed, either as self-portraits or even as authentic Rembrandts. In fact it is quite likely that Rembrandt and Jan Lievens painted each other as studio exercises.

Jan Lievens' *Portrait of Rembrandt* survives and shows a very different character from the one we are already becoming used to. Instead of the introspection and furrowed brow there is a slightly quizzical look, which can be interpreted as a symbol of searching intelligence. In sitting to Lievens, Rembrandt has not abandoned his fancy dress, thus retaining his slightly extravagant air. In terms of general style Lievens has given the painting all the polish with which he made his reputation. This painting dispels the idea that a number of the problematic Rembrandt self-portraits should be given to Lievens on grounds of both style and quality. In this area at least, the two painters are quite different from one another.

A good example of a disputed picture is the *Portrait of Rembrandt*(?) in the Clowes Collection at Indianapolis (Plate 12). The lighting scheme in this small panel is derived from the Munich and Kassel pictures, but the handling of the paint appears to be quite different. It requires a certain effort of the imagination to accept that this curious face really is Rembrandt himself and another effort to believe that he could have painted it. Yet of all the self-portraits in existence this one was the most copied. Perhaps it was used as a studio model and was given to students to copy as an exercise because of its complex lighting scheme. An attribution to Jan Lievens himself has been suggested which is unreasonable in the light of the *Portrait of Rembrandt* by Lievens (fig. 3).

The etched self-portraits from the Lieden years are some eighteen in number. Only ten more survive from the long period in Amsterdam. They do not relate to each other in any formal way. Instead they astonish by their variety. From the point of view of etching technique there is strong opposition between the robustness of the *Self-portrait with a fur cap in an oval* (B.12) of 1629-1631 and the refinement of the *Self-portrait in a soft hat and embroidered cloak* (B.7) of 1631. This passionate interest in etching technique, which Rembrandt was to take to a higher degree of subtlety than any previous artist, is the reason why the self-portraits seem rather disjointed. Taken individually they have a directness of vision often lost in the oil paintings simply because the colours have darkened. In fact the very variety of the etchings provides

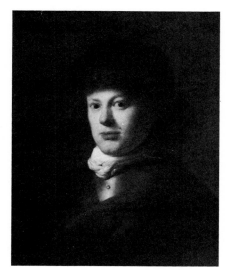

fig. 3 Jan LIEVENS
Portrait of Rembrandt
Amsterdam, Rijksmuseum, lent by a private collector.
Oil on panel 57 x 44.7 cm. Monogrammed lower left: IL.
The painting is usually dated about 1629, which accords well with Rembrandt's appearance at this time as seen in the *Self-portrait* in the Gardner Museum, Boston (Plate 20).

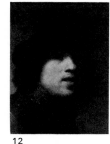

12

5

23

[19]

13

a plausible background to the major differences between some of the paintings in these years. Consistency was the last thing in which the young Rembrandt indulged.

Even more remote from the youthful images in the Kassel and Munich pictures is the so-called *Self-portrait* in the Rijksmuseum, Amsterdam (Plate 13). The face is quite different and appears very much older although there is a possible explanation for this. In the late 1620s Rembrandt produced many etchings which are experiments in facial expression. He used his own face as the model and it is quite possible that the Amsterdam picture is an unusual exercise in oil paint of an idea Rembrandt normally preferred to express by the use of the copper plate. The face appears rather older than Rembrandt was at the time (nobody has doubted that the picture dates from the Leiden period), but there is at least a superficial resemblance to the painter himself. Taking one stage further the idea that the picture is a deliberate exercise in expression it could then be interpreted as the head of Democritus, 'the laughing philosopher'. Such pictures were very popular in the 1620s, especially in Utrecht, and were usually painted in pairs, the second picture being of Heraclitus, 'the sad philosopher'.

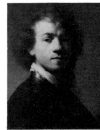

14

The best picture up to this point, by common consent, is the *Self-portrait* in the Mauritshuis, The Hague (Plate 14). The picture is very small and has a beautifully polished surface which hides the brushwork in order to create the convincing illusion of a brilliantly lit face emerging from the shadows. Some writers have preferred to note the influence of Caravaggio rather than credit Rembrandt with the achievement by observation from nature direct. The art of Caravaggio was certainly influential in Utrecht in the 1620s, but the Italian's sense of drama never really affected Rembrandt's self-portraits directly. The picture in The Hague has too great a sense of observed nature and technical finesse and has none of the feeling of a contrived derivation from another painter. It is generally thought to have been painted about 1629 and it is the first self-portrait which does not rely on an exaggerated expression. The laughter has disappeared entirely. Instead Rembrandt has become totally preoccupied with the surface appearance of things, for instance the old-fashioned costume with the studded collar. In fact Rembrandt painted himself in everyday dress very rarely (for an example see the *Self-portrait* (Plate 40) in the Burrell Collection, Glasgow) much preferring elaborate costumes which are mostly Italian sixteenth-century in style.

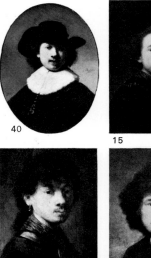

40

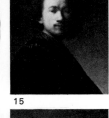

15

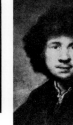

16

17

The very strength of The Hague picture can be seen by comparing it with the less refined but possibly still authentic picture (Plate 15) in a New York Private Collection. There is a similar lighting scheme and composition but the whole appears rather less crisp, as if the painter was repeating himself. Indeed The Hague picture is so superior in quality that it makes all the other self-portraits of the Leiden period appear problematic. In isolation the two little heads in the Fogg Art Museum, Cambridge, Massachusetts (Plate 16) and that formerly in the Louden collection at Aerdenhout and now with Cramer in The Hague (Plate 17) are distinguished but they falter when The Hague picture is kept in mind. Both of these pictures have been disputed by various authorities. The Cramer work is especially interesting. It is dated 1630 and it already shows the curious thickening of the nose and

lips which was to be such a characteristic of Rembrandt's face in his later years. It forms a premonition of the way the painter's face was to change in the thirty-nine years of life left to him. In general technique the picture conforms to the Leiden period but at odd points like this Rembrandt seems to have anticipated his later style. This is especially obvious in the rapidity of the brushwork, built up in this case in transparent layers and then brought together with finely detailed work on the features of the face.

Rembrandt's restless experiments with technique are also obvious in the two small self-portraits in the Metropolitan Museum of Art, New York (Plate 18) and the Nationalmuseum, Stockholm (Plate 19). The handling of the paint has changed again, becoming much more nervous, but the facial type and lighting remain constant. These two pictures are likely to be rather similar in date; the hair is almost identical and only the facial expressions are subtly different. There is still the same preoccupation with surface observation, but for the first time Rembrandt is beginning to depict his mood. The New York picture for instance has a greater degree of self-assurance, particularly when compared to the almost shifty look in the eyes in the Stockholm work. Recently, however, the museum has discovered that in their opinion the painting is much later in date than Rembrandt's lifetime. If this should eventually prove to be so it testifies to a later artist's cunning understanding of Rembrandt's development and should act as a grave warning to connoisseurs and scholars alike. It would of course be quite logical to see in the Stockholm picture a prelude to the mature style of the 1650s where introspection appears much more important than surface observation. But before Rembrandt arrived at a totally candid approach to himself in late middle-age he went through a whole series of experiments with his own face which reflects the infinite variety of the other aspects of his art.

Just as there is no real indication prior to 1632 that Rembrandt was at all capable of painting the elaborate *The Anatomy Lesson of Dr Tulp* in the Mauritshuis, The Hague, there is no suggestion that his self-portraits were to take such a step forward in both scale and skill of execution as is seen in the two pictures in the Isabella Stewart Gardner Museum in Boston (Plate 20) and the Walker Art Gallery, Liverpool (Plate 21).

The two pictures are rather similar, as if Rembrandt often made a second version after having made the initial experiment. Both pictures are very minutely painted and both have a complex lighting scheme where the light appears partly from behind and partly from an unidentified source in front of the picture. In the Boston picture the artist is wearing an extravagant plume which is used by Rembrandt as an excuse to display his skill with a difficult surface. In the Liverpool picture the skill is lavished on the golden chain glistening in the half-shadow. The Boston picture is dated 1629 which makes it plausible to consider that the Liverpool work was probably painted at about the same time. This stylistic observation is reasonable, although not certain, but is of crucial importance as even the suggestion that it could be later (and this had been made) would weaken the argument that it was indeed the picture which belonged to Charles I after it was brought to England in 1629.

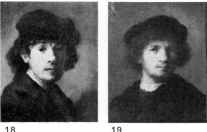

18 19

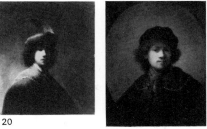

20

21

[21]

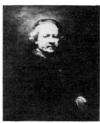

96

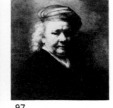

97

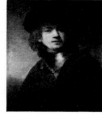

22

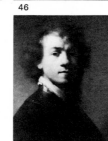

46

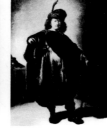

14

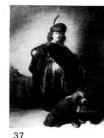

37

38

It is not an accepted method of modern art history to argue the painter's chronology by using such features as the length of his hair or the appearance of his moustache. But the fact remains that there are enough dated portraits to act as a firm basis round which the undated ones can be placed. A sensible approach, not always followed, is to consider the artist's physical appearance. Analysis on grounds of style is notoriously difficult and can often be proved quite wrong. The best example of such a calamity is the *Self-portrait* of 1669 in the National Gallery, London (Plate 96) which was always dated in the 1650s on stylistic grounds. When the remains of the actual dates were discovered on the picture in a recent cleaning, it took its place naturally as a companion to the other *Self-portrait* from the same year in the Maurits-huis, The Hague (Plate 97).

If this line of argument is pursued it becomes obvious that the well-known *Self-portrait* in the Uffizi, Florence (Plate 22) has been dated several years too late. The picture is very well painted and critics were obviously unwilling to admit that it could date from the Leiden period. Bredius compared it to the equally celebrated *Self-portrait* of 1634 in Berlin (Plate 46). However all the dated self-portraits from 1631 on-wards show Rembrandt wearing a moustache and all the earlier self-portraits show him to be clean-shaven. Fortunately this is not the only reason for favouring an earlier dating. The picture appears to be quite a reasonable sequel to the Liverpool and Boston pictures and continues the finesse of The Hague *Self-portrait* (Plate 14). Furthermore a careful comparison with the Berlin *Self-portrait* of 1634 makes the pose of the Uffizi picture seem slightly awkward. The structure of the shoulder is conveniently hidden by the armour and the artist has concentrated entirely on the surface glitter. All this favours a Leiden period dating.

Perhaps the last picture Rembrandt painted before he left for Amsterdam is the full-length *Self-portrait with a Dog* in the Musée du Petit Palais, Paris (Plate 37). Gerson thought that the picture was by a Leiden follower but the composition and lighting are much too clever to have been invented by a follower. Jan Lievens, for instance, never painted like this and his difference from Rembrandt is clearly seen in the signed and dated *Raising of Lazarus* of 1631 in the Brighton Art Gallery. This picture almost certainly belonged to Rembrandt and although it is possible that Rembrandt was influenced by Lievens' imaginative composition, the two artists handled paint quite differently by this date. The very similar portrait (Plate 38), which does not include the dog, has not been seen for many years and comment on its quality is not at present possible.

The Amsterdam years: 1632 – 1669

[i] The years of success 1632–1642

The move to Amsterdam was quite naturally a great change in Rembrandt's life, although it must not be forgotten that Leiden had been the largest town in the Dutch Republic until it was overtaken by Amsterdam at about this time. Immediately on his arrival he painted *The Anatomy Lesson of Dr Tulp,* his first important public commision.

The *Self-portrait* (Plate 40) in the Burrell Collection, Glasgow, dated 1632, the same year as *The Anatomy Lesson,* is painted in a similar polished style. By this time Rembrandt had already achieved the very difficult task of producing an illusion of three-dimensional reality. This skill must of course have pleased his patrons enormously. The methods used are extremely subtle. In the Glasgow picture there is infinite tonal variety in the completely plain background, allowing the outline of the figure to vary in sharpness against it and therefore to give the illusion of slight movement. Apart from the sheer technical advance the Glasgow picture is unusual on another level. For once Rembrandt abadoned fancy dress and presented himself as a young bourgeois without the slightest indication that painting was his profession. Indeed the attributes of the craft of painting only appear in his self-portraits towards the end of his life (Plates 89, 91 and 98).

The minute *Self-portrait* in the Philips Collection at Eindhoven (Plate 39) in all likelihood dates from this time, as in general style it is quite close to the two oval *Self-portraits* in the Louvre (Plates 44 and 45), both of which date from 1633. These two pictures represent a considerable change from the Glasgow picture of the previous year. Rembrandt returned to the old-fashioned and romantic dress already familiar from the earlier pictures. He allowed the golden chain to be prominent instead of the then fashionable starched white collar. It is also quite noticeable from both pictures that Rembrandt's face was undergoing rapid ageing. His cheeks were filling out and his eyes were assuming that curious heaviness which was to remain with him for the rest of his life.

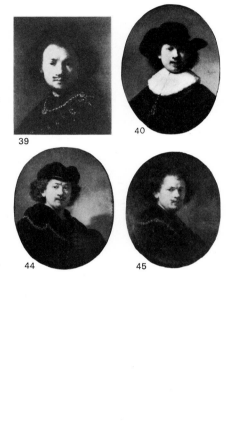

39 40

44 45

It is no use assuming that these rather worried looking pictures show an impending personal crisis, particularly as Rembrandt was about to enter the most successful period of his whole career. Indeed it is quite possible that many of the myths which grew up around Rembrandt were derived from the self-portraits. They were used to prove the myth of which they were the source. Until the last ten years of his life Rembrandt depicted himself in so many different attitudes and moods that no one of them can be reasonably used to denote a general trend. In a number of instances, especially in the Leiden period, the heads are exercises in expression and not specifically self-portraits. The Louvre pictures are not a pair although they are very similar to one another. The one without the cap is the more solemn of the two and in both the artist's face is half enveloped in shadow rather softer than that used in the Leiden period pictures. Rembrandt was already moving towards the achievement of being able to diffuse the light in his pictures to such an extent that the very paint itself appears to be glowing.

This gradual self-fulfilment took many forms. The change of approach in the celebrated *Self-portrait* in Berlin of 1634 (Plate 46) is abrupt. Rembrandt suddenly appears much more self-confident; the unease of the Louvre pictures evaporates and the pose becomes much more elaborate, especially in the way the head is subtly inclined and turned on the shoulders. The whole picture is a tour de force of illusionism. The shoulder, hair and cap form an elaborate pattern against the plain but shadowed background.

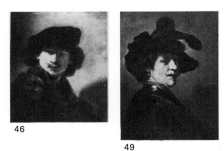

46 49

Rembrandt's preoccupation with detail is taken to an equally exquisite extreme in the undated *Self-portrait* in the Mauritshuis, The Hague (Plate 49). The Berlin picture is rightly regarded as being one

of the best from the 1630s and at the age of twenty-eight Rembrandt had come into full control of his power. From this point onward there could be no more improvement, only change. It is a fallacy that great painters must always work towards a climacteric and the falseness of this approach is underlined by the widely differing opinions which have been held concerning which decade is Rembrandt's 'best' period. After the years of experiment in Leiden he was in total control of himself. From then on he could paint as an idea seized him. In the Berlin picture he had achieved an enormous power which was never to leave him.

The artist's features appear rather heavier in The Hague *Self-portrait,* as if he was already middle-aged by the time he was thirty. He was already developing his interest in losing parts of the picture in shadow and allowing greater concentration on certain highlights and details. Pictures of this type are continuously reminiscent of his society portraits of the period, for example the *Philips Lucasz.* of 1653 in the National Gallery, London.

Rembrandt's fondness of extravagant costume had already dominated most of his self-portraits and in the picture at Kassel (Plate 50) he depicted himself in full armour with a cloak thrown over it. The artist's gaze is particularly intense, just as if he were looking very hard into the mirror. An amusing derivation of the Kassel painting in the Bernard Solomon Collection, Los Angeles, shows how easily the Rembrandt type could be assimilated by a later hand. The same elaboration is taken further in the picture formerly in the collection of the princes of Liechtenstein (Plate 51). The artist's face appears almost lost amongst so many feathers and so much armour and finery. The pictures of this type have suffered much criticism in recent years because they do not fit into the purist approach to Rembrandt. They are of course quite consistent with the extrovert and extravagant side of his character. However, the weakness of the self-portraits in Berlin (Plate 52) and the Louvre (Plate 56) may be explained by the possibility that Rembrandt encouraged his pupils to paint him. There is for instance a recently discovered *Portrait of Rembrandt* in an American private collection. It shows how the artist would have appeared in the mid-1630s and has a similar composition to the Louvre picture. The style is that of Govert Flinck and it must be one of his earliest works. Bredius accepted the *Portrait of Rembrandt* in the City Art Gallery and Museum, Glasgow as an authentic self-portrait, though it is clearly derived from the Louvre picture. There are very definite differences between the two; the Glasgow work is much more relaxed, perhaps because the painter was not having to perform the difficult task of painting himself at the same time as looking into a mirror. Most authorities now give the Glasgow picture to Flinck, who was Rembrandt's pupil in the mid-1630s. A much more convincing *Portrait of Rembrandt* by Flinck is in the National Gallery, London. Its self-assuredness calls into question the generally held assumption that inferior pictures close to Rembrandt are by Flinck. The Berlin and Louvre pictures sit on the borderline between Rembrandt and Flinck because of their character rather than their quality. Flinck was a highly accomplished but unimaginative painter, and produced the delightful *Portrait of Rembrandt dressed as a Shepherd* in the Rembrandthuis, Amsterdam.

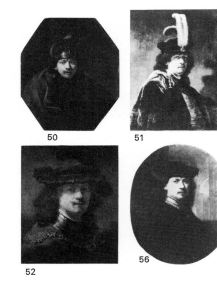

50 51

52 56

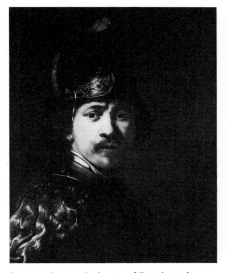

fig. 4 unknown imitator of Rembrandt
Portrait of Rembrandt
Los Angeles, Bernard Solomon Collection.
Oil on panel 62.8 x 48.5 cm.
The painter has been happy to imitate
Rembrandt's tricks of lighting and brush-
work without understanding the structure
of the Kassel *Self-portrait* (Plate 50).

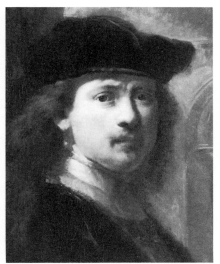

fig. 5 Govert FLINCK
Portrait of Rembrandt
America, Private Collection.
Oil on canvas 49.5 x 39.5 cm.
Unsigned.
This picture shows Rembrandt in the mid
1630s.

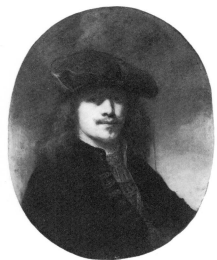

fig. 6 Govert FLINCK
Portrait of Rembrandt
Glasgow, City Art Gallery and Museum.
Oil on panel 66 x 51 cm. Unsigned.
This picture was probably painted in the
1630s. A somewhat similar picture of
Rembrandt by Flinck, signed and
dated 1639, is in the National Gallery,
London (fig. 7).

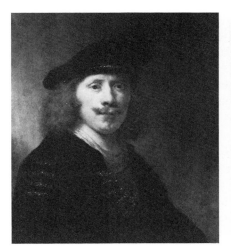

fig. 7 Govert FLINCK
Portrait of Rembrandt aged about thirty-three
London, National Gallery.
Oil on panel 65.8 x 54.4 cm.
Signed and dated lower right: G. Flinck
1639.
A haunting and underestimated picture.
Flinck's observation of Rembrandt was
amazingly close to Rembrandt's own.

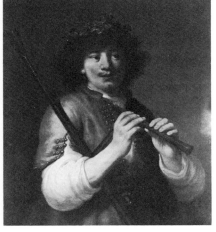

fig. 8 Govert FLINCK
*Portrait of Rembrandt (?) dressed as a
Shepherd*
Amsterdam, Rembrandthuis (on loan from
the Rijksmuseum, Amsterdam).
Oil on canvas 74.5 x 64 cm. Signed:
G. Flinck F.
From Rembrandt's apparent age the
picture was probably painted in the mid-
1630s.

[25]

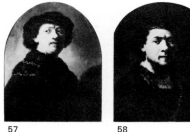

57 58

The rather similar pictures in the Wallace Collection, London (Plate 57) and Museu de Arte, Sao Paulo (Plate 58) have also posed problems. The London picture is painted from a low viewpoint and gives the sitter an unusually domineering look. By comparison the Sao Paulo picture appears much less tense, again suggesting the possibility that it was done from another picture and not from life. Even in the London picture those standards which are Rembrandt's own are only just present.

By the middle of the 1630s Rembrandt had painted, or his pupils and imitators had manufactured, more than half the self-portraits known today. It comes as no surprise, therefore, to note that the 1630s were the period when Rembrandt included himself most frequently in his subject pictures, either as a model, or as the main sitter. As has already been pointed out he had done so before, somewhat tentatively, in those very first Leiden pictures (figs. 1 and 2) but now he had so much more self-confidence that he had not the slightest hesitation in making himself the very centre of the drama.

Rembrandt put himself as a prominent character in two of the pictures from the *Passion Series* in the Alte Pinakothek, Munich which were painted for the Stadhouder Prince Frederick Hendrik over a period of years in the 1630s. Rembrandt's face is clearly recognizable at the foot of the Cross in *The Raising of the Cross,* and sometimes painters, especially in Italy, included themselves in their pictures, even depicting themselves as Christ Himself, as did Dürer in the picture in the Alte Pinakothek, Munich.

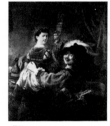

59

In addition to the *Passion Series* there are also the two genre pictures, both in Dresden (Plates 59 and 63), where Rembrandt makes himself the main figure. Many different interpretations have been put forward for the *Self-portrait with Saskia.* The current favourite is *The Prodigal Son Dissipating His Patrimony.* But whatever the picture's subject may eventually turn out to be, nobody has doubted the fact that the sitter is Rembrandt himself with Saskia on his knee. This is one of the few pictures which give any positive indication of an alternative side of Rembrandt's character, a side, however, which Fromentin saw in his analysis of the Louvre *Self-portrait* of 1633 (see Plate 45). This is the luxury-loving, extrovert and successful Rembrandt. And it is the side of his life that is actually proved by the documents. Extravagance is the keynote of the 1656 insolvency inventory. Rembrandt's house was full of baubles and curiosities as well as bourgeois necessities and the tools of his trade. Saskia is known to have been the daughter of a bourgeois from Leeuwarden and when she died prematurely in 1642 she left Rembrandt a small income.

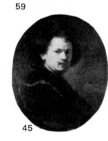

45

The Dresden *Self-portrait with Saskia* gives a much closer insight into the realities of Rembrandt's daily life than has been realised before. To take the point further, many of the self-portraits of the artist's middle years show him dressed as a Renaissance man. They show the painter of *The Night Watch* as a rival to the Italian tradition, and not as he really was. It may well be that many of these self-portraits were demonstrations of his abilities, displayed in order to impress prospective patrons; a kind of showing-off which had nothing to do with self-analysis.

The *Self-portrait with a Dead Bittern* (Plate 63), the other Dresden genre

63

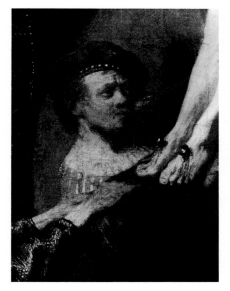

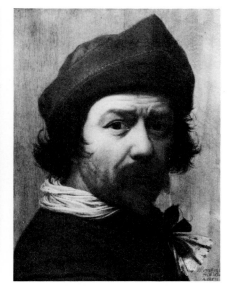

fig. 9 REMBRANDT
The Raising of the Cross (detail)
Munich, Alte Pinakothek. Oil on canvas
96 x 72 cm. Unsigned.
This picture was probably painted about
1634.

fig. 10 REMBRANDT
The Descent from the Cross (detail)
Munich, Alte Pinakothek. Oil on panel
89.5 x 65 cm. Signed: C. Rhmbrandt f.
This picture was probably painted about
1634.

fig. 11 Huygh Pietersz. VOSKUYL
Self-portrait
The Hague, Mauritshuis. Oil on panel
31.9 x 42.4 cm. Signed and dated lower
right: H P Voskuyl fe. Ao. 1638 Aetatis
Suae 46.

picture, has also been rather neglected by critics because it too shows a self-confident Rembrandt in the role of the hunter and emphasizes his individuality. It is not known whether he indulged in this then common pastime but he was certainly often in the countryside around Amsterdam as so many drawings of it by his hand survive. In the Dresden picture the dead bird dominates the composition and it is almost as if it was painted as a demonstration of the artist's skill. The face is reminiscent of the Berlin *Self-portrait* of 1634 (Plate 46) and still has that slightly insouciant look.

46

That Rembrandt was slowly moving into isolation as a painter is obvious by 1642 because his execution of *The Night Watch* changed the whole course of Dutch painting. There are no kindred spirits among his contemporaries. The accidental nature of our present knowledge of Dutch seventeenth-century painting has already been emphasized. Huygh Pietersz. Voskuyl (Amsterdam *c.* 1592/93 – Amsterdam 1665) is a painter whose *œuvre* is at present limited to four surviving pictures. His signed and dated *Self-portrait* of 1638 in the Mauritshuis, The Hague succeeds in creating an illusion of reality by careful observation that parallels Rembrandt's interests in this direction. It is quite possible that Rembrandt knew the Voskuyl portrait when he painted the *Self-portrait* in the Norton Simon Gallery, Los Angeles (Plate 64); the poses are very similar and Rembrandt has used an unusual crispness of execution.

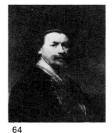

64

The culmination of this particular approach is seen in the 1640 *Self-portrait* in the National Gallery, London (Plate 65). It is exceptional in several ways, being the most highly finished self-portrait of this period and the one which shows the greatest debt to the Italian Renaissance. Rembrandt's reliance on the past in this picture is complex, as he never plagiarized directly, filtering the foreign idea through his own imagination. Rembrandt made a drawing of Raphael's *Portrait of Castiglione*,

[27]

fig. 12 TITIAN
Portrait of a Man
London, National Gallery. Oil on canvas
81.2 x 66.3 cm.
Formerly inscribed: TITIANVS TV.
This portrait, formerly called *Portrait of Ariosto,* is generally dated about 1512.

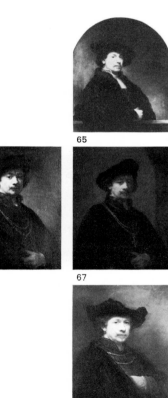

now in the Louvre, when it passed through an Amsterdam saleroom and it is usually said that he based the London picture on it. But the composition is in fact very much closer to Titian's so-called *Portrait of Ariosto* in the National Gallery, London which passed through a Paris saleroom in 1641. In this self-portrait Rembrandt took more trouble than in any other work to depict himself in a sober but intricate sixteenth-century costume. The handling of the paint is unusually precise and this displeased Emile Michel (see p. 42). There was in fact a tendency in the 1640s for painters in Amsterdam to make their work more and more highly finished as did Bartholomeus van der Helst, the most fashionable portrait painter at the time. Rembrandt was moving in quite the opposite direction but was capable of changing his style to suit the needs of the moment.

[ii] The artist's maturity 1642–1660

The 1640s are a relatively obscure period in Rembrandt's art as the number of surviving pictures diminished quite sharply. The number of obviously authentic self-portraits falls and few of them are of the quality of the Berlin picture of 1634 (Plate 46). The possibility of lost works must also be taken into account. Although the relatively large number of copies made of the Leiden period pictures is not kept up, it is possible or even likely that some of the problem pictures of the 1640s reflect one or more lost originals. No logical explanation can be found for this, especially as Rembrandt's personal difficulties are known to have increased in the 1650s, which was a period of great creativity. The death of Saskia in 1642 could well have been the cause of problems in Rembrandt's artistic life, but the historian has no right to draw such conclusions without better evidence.

The two very similar self-portraits (Plates 66 and 67) at Woburn Abbey and Ottawa are anticlimactic in terms of quality after the London picture. This is not a good enough reason to deny their authenticity but the fact that they are very similar to one another in composition, style and quality indicates the possibility of the existence of a lost original to which they are both related. The crispness of the London picture is not there and this rather tired approach is even true of the *Self-portrait* in the Royal Collection at Windsor Castle (Plate 69) where the whole image seems blurred. Rembrandt has hidden himself in shadow and his gaze has become blank rather than introspective.

A rather better work in this group is the *Self-portrait* now in the Thyssen collection at Lugano (Plate 68). Similar in composition to the Windsor picture, it is in its strength of handling rather closer to the London *Self-portrait* of 1640.

The only dated picture from the 1640s is the unfortunate *Self-portrait* formerly in the Stadtmuseum at Weimar of 1643. It has been taken away from Rembrandt in recent years but he is certainly the sitter and the slightly bored look may well indicate that Rembrandt was unhappy at being painted by one of his pupils. Since it was stolen from the Weimar museum in 1921 this picture has been inaccessible, although it was once exhibited at Washington. Comment on it is therefore difficult.

fig. 13 attributed to REMBRANDT
Self-portrait
formerly Weimar, Stadtmuseum. Oil on
canvas 61 x 48 cm.
Signed and dated centre left: Rembrandt f.
1643.
According to Gerson this picture is probably
by or after Ferdinand Bol. It was stolen
from the Museum in 1921, and in recent
years reappeared in America.

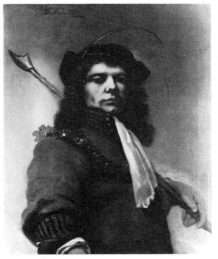

fig. 14 Barent FABRITIUS
Self-portrait
Vienna, Akademie der bildenden Künste.
Oil on canvas 79 x 64.2 cm. Signed upper
left: B. Fabritius.
This picture was probably painted about
1650.

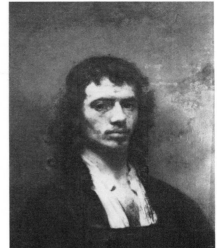

fig. 15 Carel FABRITIUS
Self-portrait
Rotterdam, Museum Boymans-van
Beuningen.
Oil on panel 65 x 49 cm. Signed upper
right: fabritius f.
For many years this picture was thought
to have been painted in 1645 but it is now
considered to date from 1654, in which
year the painter was killed in the
explosion of the powder magazine at Delft.

About 1650 Rembrandt seems to have started a new burst of activity
and a fresh group of pupils matured under his influence, in particular
the brothers Barent and Carel Fabritius, who had both worked in the
studio in the 1640s. Barent Fabritius's *Self-portrait* in the Akademie der
Bildenden Künste at Vienna owes quite a lot to Rembrandt in the way
it is painted but the concept is quite original and shows how Rem-
brandt's better pupils were able to interpret his genius without being
overwhelmed by it. The situation becomes more complex with Barent's
brother Carel. He probably painted himself on a number of occasions
and the sublime picture in the Museum Boymans – van Beuningen at
Rotterdam has usually been considered to be a self-portrait. It is
thoroughly Rembrandtesque in treatment without sacrificing one scrap
of originality of vision. Carel Fabritius is the only one of Rembrandt's
pupils who understood his art and who was therefore able to transcend
it. The little *Portrait of Rembrandt* in Leipzig used to be attributed to
Rembrandt himself but was then given to Fabritius, an attribution also
now rejected. The handling of the paint is close to the *Man in a helmet*
by Fabritius at Groningen and the painting does not relate satisfactorily
to Rembrandt's known pictures of about 1650. It also underlines
Fabritius's originality. All his surviving pictures are diverse but they
are held together by his unmistakably individual vision. He liked to
place his sitters, his goldfinch, his sleeping sentinel against a light back-
ground exactly as in the Leipzig picture. Its dating is difficult but it
must of course be before 1654, in which year the painter was killed in
the explosion of a powder magazine at Delft.

The *Self-portrait* in Washington (Plate 73) is dated 1650 and the
rather similar picture in Karlsruhe (Plate 72) must be from about the

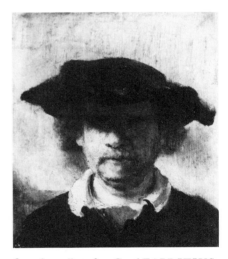

fig. 16 attributed to Carel FABRITIUS
Portrait of Rembrandt
Leipzig, Museum der bildenden Künste.
Oil on canvas 26 x 21.5 cm. Unsigned.
This picture, attributed to Carel Fabritius
until recently, was probably painted about
1650.

[29]

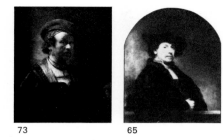

73 65

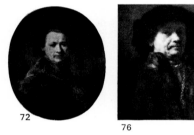

72

76

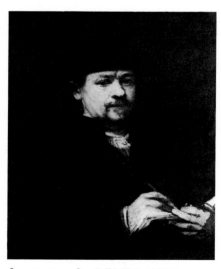

fig. 17 copy after REMBRANDT
Self-portrait
Rousham House, Oxfordshire, collection
of C. Cottrell-Dormer. Oil on canvas
75 x 63 cm. Unsigned.
This picture is a virtual copy of the
Dresden *Self-portrait* (Plate 80) of 1657.

same time. It is as if Rembrandt suddenly took up where he had left off in the London picture of 1640 (Plate 65). The real development is in the lighting. In the Washington picture it is especially complex and its very unexpected appearance at this date was one of Gerson's reasons for doubting the authenticity of this famous picture. It is one of Rembrandt's skilful exercises in the painting of reflected light if it is not the eighteenth- or nineteenth-century imitation Gerson believed it to be. The picture must in fact date from before 1836, the year in which Smith praised it. This mythical Rembrandt imitator, compounded by Gerson must have had an uncanny grasp of Rembrandt's chronology and has made the length of the artist's hair exactly in keeping with the other pictures of this time. He must also have been a good tailor, painting a Renaissance costume of the type used by Rembrandt. Another indication that the picture really is a self-portrait is the position of the eyes. When an artist paints a model whose head is slightly turned away, the sitter quite naturally looks in front of him and not at the painter. In the Washington picture Rembrandt's eyes are at an angle because he had to turn his eyes in order to see himself in the mirror. It could further be argued that the constant strain and difficulty in doing this (and those who have tried will know) produced the furrowed brow and slightly exasperated expression seen in some pictures.

The Karlsruhe *Self-portrait* (Plate 72) must be close in date to the Washington picture because of the age of the sitter. Uniquely the moustache has disappeared. Rembrandt could well have removed it briefly because it appears in a slightly modified form in the later pictures. The Karlsruhe picture reflects a type familar from the 1630s with an oval format and frontal pose. But how different Rembrandt appears from the confident figure in the *Self-portrait* in the Burrell Collection, Glasgow.

In the Vienna *Self-portrait* of 1652 (Plate 76), the change which took place in Rembrandt's approach to himself and also in his style of painting is the most marked in his whole career. The lighting, the face itself and the handling of the paint are all transformed. Rembrandt placed himself frontally with his hands on his hips and used a much freer handling of the paint. His face has become an almost rocky surface of crags and hollows quite unlike the realistic flesh seen in the Karlsruhe picture. The Vienna picture is of great importance as a new departure because from this point onwards Rembrandt's self-portraits show little further development. He continued to refine his approach but changed his technique little. This is also true of his other paintings. After the *Polish Rider* (Frick Collection, New York) of the mid-1650s, the changes of style are minimal compared with the constant experiment in his earlier work. Rembrandt was still capable of painting the unexpected in the form of the sketch at Aix-en-Provence (Plate 84), but his range was much more limited. Perhaps it is the very consistency of these last fifteen years of his life that have led this period to be admired in the twentieth century above all his other work.

It has always been said about these mature and late self-portraits (Plates 78-98) that Rembrandt laid himself bare as a man and exposed his real character. This cannot be true because if only his self-portraits had survived it would be difficult, if not impossible, to imagine the tenderness of feeling in the *Jewish Bride* or the dignity in the so-called

Alexander (Glasgow, City Art Gallery and Museum). Indeed in many ways the solemn mood of many of these later self-portraits is quite unlike the rest of his art. Rembrandt's later pictures from the *Conspiracy of Claudius Civilis* (fragment, Nationalmuseum, Stockholm) to the *Lucretia* (Institute of Arts, Minneapolis) are the product of an ever-expanding imagination and each one makes an entirely new statement about humanity.

By contrast the self-portraits continue, inexorably, examining and re-examining the same theme. The same motifs are repeated. The small *Self-portrait* in Vienna of 1655 (Plate 78) is very close to the Kassel picture (Plate 77) of the previous year and also to the related picture in the Uffizi in Florence (Plate 79). The latter appears less strong than the Vienna work and in recent years it has been called a copy. If this is so the original of the composition is not known and the painter concerned must have made a convincing variation on a Rembrandt theme.

There are a further group of problem pictures dating from the 1650s which could indicate a renewal of interest by Rembrandt's pupils or a preference for pictures of this period by later copyists. The most difficult problem centres round the Dresden *Self-portrait* of 1657 (Plate 80). When the undoubted original of a composition is known copies are easy to detect and dismiss, but the pictures related to the Dresden work seem to be variants. The Dresden picture by itself fits quite easily into the late 1650s, the painter's face emerges almost hesitantly from the shadows, and, unusually, he has shown himself with pen or brush (it is not clear which) in his hand.

The variant of the Dresden picture in San Francisco (Plate 81) seems less assured and the observation of character is less intense. It thus gives the air of being derived from the Dresden work rather than exactly copied from it, and when seen in the museum completely lacks the tautness that is found in all Rembrandt's work. The other two versions, one at Rousham, Oxfordshire and the other in a private collection in America, are even further away from the Dresden picture. The Rousham picture has been given much recent publicity as a demoted Rembrandt, but without the observation that in all the vast literature devoted to the painter, only Hofstede de Groot and Bauch accepted it.

Those who feel that the present writer is being too severe and that the San Francisco picture should be restored unequivocally to Rembrandt should bear in mind the height of achievement in these years. The *Self-portrait* in the collection of the Earl of Ellesmere (lent to the National Gallery of Scotland, Edinburgh) (Plate 82) is one of the best of all the pictures from the 1650s. Over the last hundred years it has had a chequered history and in its present state is incomplete. It was engraved as the frontispiece to John Smith's *Catalogue* of 1836 and then its dimensions were those of the usual self-portraits from these years, with a good proportion of the torso visible. Now the head fits uneasily into the square which is too small for it. The reason for this is that some time about 1933 the picture was cut down in the belief that it had been enlarged by a hand other than Rembrandt's. As there are several other examples of Rembrandt's pictures being enlarged, probably by himself, it was obviously a folly to reduce the picture to a format never intended by the artist.

In painting the Edinburgh head Rembrandt left nothing to the

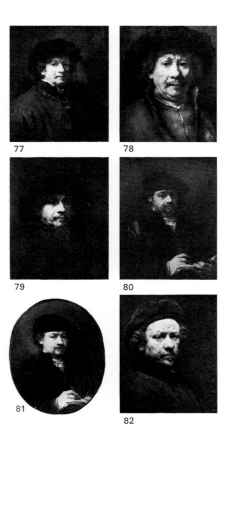

77 78

79 80

81

82

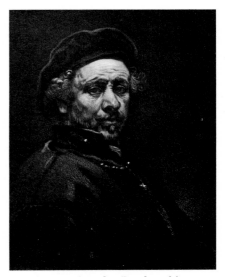

fig. 18 engraving after Rembrandt's *Self-portrait* at Edinburgh (Plate 82) This engraving from the Edinburgh *Self-portrait* was used as the frontispiece for John Smith's *Catalogue Raisonné* of 1836. The dimensions are those before its restoration by Dr A. M. de Wild in 1933.

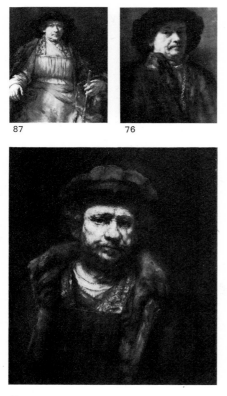

87 76

fig. 19
Portrait of Rembrandt
Stuttgart, Staatsgalerie.
Oil on canvas 68 x 56.5 cm.
Unsigned.
First recorded in a private collection in
Palma, Majorca, in 1958. It was acquired
by the museum in 1971. Obviously close in
style to Plate 87, but not by Rembrandt.

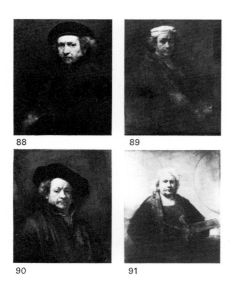

88 89

90 91

imagination. He treated himself exactly as if he were a society sitter who wished for an accurate record of himself. Perhaps it is the unobtrusive truth of the Edinburgh picture which has led it to be overshadowed by the grandiose and brilliant *Self-portrait* of 1658 in the Frick Collection, New York (Plate 87). The pose in this picture is unique. Rembrandt is seated with his arms outstretched and his legs slightly apart, thus forming a pyramidal composition. In no other self-portrait is there so much bright colour. A great splash of red and yellow is laid on with great freedom and then covered with filmy glazes of both colours. Only this once did Rembrandt permit such extravagance of colour and brushwork. The details are blurred and melt into one another, so much so that the lower parts of the figure are inaccurate. The face still dominates the picture, and the room in which it hangs, with a peculiar force. The face is in fact the type familiar from the Vienna *Self-portrait* of 1652 (Plate 76) and shows how little Rembrandt was prepared to alter the way he saw himself right through the 1650s.

A corruption of the Frick picture is found in the so-called *Self-portrait* in the Staatsgalerie at Stuttgart. Whatever its final status may be it can only be derived from the Frick composition.

The Washington *Self-portrait* (Plate 88) of 1659 is rather different. For the first time the painter appears tired, there are more lines round his eyes and his hands are totally blurred and quite unlike those in the Frick picture. After the almost emaciated face of the Washington picture the old self-assurance returns a little in the Louvre *Self-portrait* (Plate 89), where he depicted himself holding his palette. This is unusual because all his life up to this point Rembrandt seemed to have been at pains to avoid showing the paraphernalia with which a painter has to surround himself. The Louvre picture is justly celebrated; it is one of the most assured and carefully balanced of the last compositions. The painter is in full control, contrasting the broad sweeps of the brush on the turban with the more detailed handling of the face.

Rembrandt's many changes of mood, or rather the moods in which he chose to depict himself, are seen in the New York picture (Plate 90) of 1660. The large hat has reappeared, the head is much smaller in relation to the whole and his face has acquired the worried look seen in the Washington picture of the previous year. Rembrandt still had nine more years of life left to him, but most of what has been written about his last years and final dissolution has been derived from familiarity with this and the Louvre picture (Plate 89). The *Self-portrait* at Kenwood House, London (Plate 91) is not dated but also falls into the group of pictures which are wrongly imagined to be the last. The Kenwood picture could well date from a little after 1660 because Rembrandt is slightly older. His face is more flaccid. Much has been said about the possible extra meaning of this solemn picture. As early as 1836 John Smith noted the 'geometrical forms' in the background, which Rembrandt avoided introducing into any of the other existing self-portraits.

These famous half-circles could well have been introduced for decorative reasons in order to enliven an unusually large expanse of plain background due to the painting being wider in proportion to its height than is usual with Rembrandt. The whole picture is slightly blurred as if the painter had avoided a single sharp contrast of tone. Rembrandt

appears to emerge from the canvas instead of being fixed upon it. The restless experiments of the earlier years are totally abandoned and in each of these pictures we learn just a little more of what Rembrandt wants to tell us. That is a curious mixture of grandeur and melancholia.

[iii] The final years 1660 – 1669

Rembrandt's last years are undeniably moving as a human story. Some documentation survives, revealing a few commissions – the *Syndics*, for instance, in which he painted the best picture in the whole of his last years. His art is instantly recognisable in both style and content simply because it is so utterly unlike that of his contemporaries.

It comes as a surprise, therefore, that problems of authenticity should cloud these last idiosyncratic years. Rembrandt had become so much of an individual that successful imitation of his late style is unlikely, particularly as he had become so unfashionable. If the pictures in Melbourne and the Fogg Museum (Plates 92 and 93) finally end up as rejected, then there are only six surviving self-portraits from these last nine years in the 1660s. This is an indication of the steep fall in Rembrandt's output which is also reflected in his other pictures. He had a far less active studio at this time and probably produced far fewer works of collaboration.

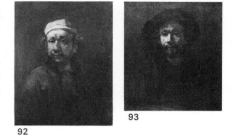

92

93

The Melbourne and the Fogg Museum pictures are quite close in style to one another and they are unlike any other self-portrait from this period. The Aix-en-Provence sketch is even further away from the accepted type of the early 1660s and this picture has been subject to widely differing opinions. Rembrandt was not on the whole given to making oil sketches although several exist from different stages in his career, a good example being *The Entombment* in the Hunterian Museum, Glasgow. But inconsistency is the prerogative of a great painter; the very orderliness of most of Rembrandt's pupils – Carel Fabritius is an exception – is the proof of their competence but lack of genius.

Rosenberg compared the Aix-en-Provence picture to Goya in its directness and Gerson doubted it altogether as a Rembrandt. Suffice it to say that those who have ever been to Aix-en-Provence have not failed to be moved by this sketch of a stern face, Rembrandt's face in both appearance and handling. It is utterly devoid of the peace and resignation seen in the Kenwood picture and naturally ruins all the carefully thought out generalisations which are so tempting for Rembrandt's last years.

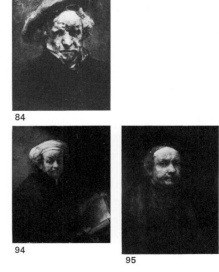

84

The very last pictures cannot fail to be touching to the modern eye because they strip away all the attributes of the Renaissance man in which Rembrandt veiled himself for so much of his life. The *Self-portrait as the Apostle Paul* in the Rijksmuseum, Amsterdam (Plate 94) of 1661 probably fits into a series of Apostles which Rembrandt did at this time (an example is in the Getty Museum at Malibu). The paint is beautifully controlled as in the *Jewish Bride* and the saint's attributes are played down. Rembrandt has given himself a slightly quizzical look. By contrast the undated *Self-portrait* in the Uffizi, Florence (Plate 95) returns to the familiar image of the old man seen gently through the shadows.

94

95

From the last year, as if by some miracle, two self-portraits survive.

[33]

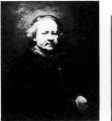
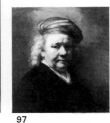

96 97

98

They are rather different, even from the late style as defined by the encrusted and glowing treatment of the *Jewish Bride*. Instead of possessing an almost molten quality, the paint surface appears much drier. How this happens is not quite clear. There is still layer upon layer of alternately thick and thin paint and subtle glazes. Perhaps Rembrandt used less oil, thus producing an almost crumbly surface.

The two pictures in the National Gallery, London, and the Mauritshuis, The Hague (Plates 96 and 97) are similar to one another. They show an exquisite skill, not in a dazzling manner, but in a quiet way. The old man built up the pictures, very slowly it seems, with dry touches of paint to indicate such details as his wispy hair.

The Hague picture is usually accepted as the very last from his hand but there is one more possibility. This is the *Self-portrait (as the Laughing Philosopher?)* at Cologne (Plate 98). The picture was somewhat neglected by the old authorities (it did not arrive in the Wallraf-Richartz Museum until 1936 and then it was obscured during the war years and after). Recently Albert Blankert devoted a long study to it, pointing out that it is clearly a fragment of a much larger picture depicting Rembrandt painting an old woman. The piece which survives is the most decayed of all the images of Rembrandt's face. In technique it is like the unfinished *Family Portrait* in the Herzog Anton-Ulrich Museum, Brunswick. If Blankert is right Rembrandt painted himself as the old philosopher laughing himself to death. This changes the old idea of Rembrandt dying surrounded by an aura of tragedy. He *is* laughing in the Cologne picture, laughter which takes us right back to the Dresden *Self-portrait with Saskia* of thirty years before.

Most of Rembrandt's last pictures tend to be somewhat joyless. They all have a certain gravity, but they are never images of despair. He continued to record himself, to accept commissions and to organize his business affairs. Thus he lived as many a man who has known great success early in life and who has had to adjust to different circumstances as he grew older, without compromising the talent which made him great. These last pictures give no indication of personal misery and desolation although it has often been suggested that they do. They lack the extravagance of the 1630s and they lack humour, but they are all the more perfectly frank statements by the man who had the greatest powers of observation of his time.

Having emphasized Rembrandt's uniqueness it is still surprising how little can be unearthed about his great contemporaries. No convincing image of Vermeer survives unless it is the artist's back in *The Artist's Studio* in the Kunsthistorisches Museum in Vienna. Frans Hals left only two records of himself, one of them only known from copies, of which the best is the small picture in the Clowes Collection at Indianapolis. The other appears in the background of the *Officers and Sergeants of the St George Civic Guard Company* at Haarlem. In both pictures Hals gives the impression that he has been honest with himself, but unlike Rembrandt has shown himself to be an ordinary member of society. Most painters followed this convention; it never occured to them that they were beings apart.

Two pictures survive which, controversial though they may be, give some insight into the appearance of a studio in Rembrandt's time. The earlier of the two is the small *Rembrandt(?) in his Studio* by Rembrandt

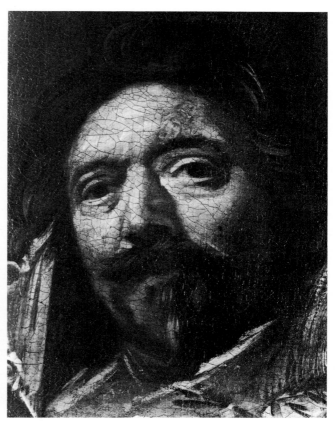

fig. 20 probable copy after Frans HALS
Self-portrait
Indianapolis, Clowes Collection (formerly Dresden, Staatliche Gemäldegalerie).
Oil on panel 34.5 x 25.4 cm. Unsigned.
This picture, although probably a copy, is generally dated about 1650 and is the best version known.

fig. 21 Frans HALS
Officers and Sergeants of the St George Civic Guard Company, Haarlem (detail)
Haarlem, Frans Hals Museum. Oil on canvas 218 x 421 cm. Unsigned.
This picture, from which a detail, believed to be a self-portrait, is shown, is usually dated about 1639.

fig. 22 REMBRANDT
Rembrandt (?) in his Studio
Boston, Museum of Fine Arts (Zoe Oliver Sherman collection).
Oil on panel 25 x 31.5 cm. (originally larger). Unsigned.
The picture was probably painted in the late 1620s.

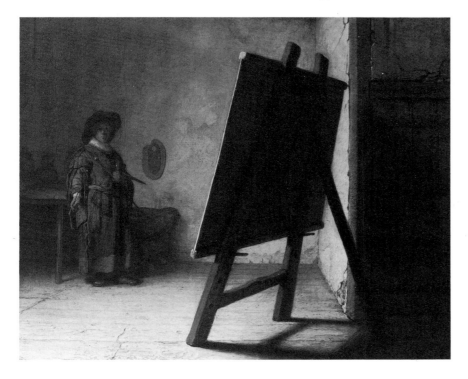

in the Museum of Fine Arts, Boston. It shows a painter who could well be Rembrandt himself standing in front of the easel in a bare room. The interior is empty to the point of desolation, the peeling plaster is made obvious. What Rembrandt intended here is difficult to work out. Many such pictures are now interpreted as a kind of 'Allegory of Contentment with Little'; here the artist has only his easel; or, more persuasively, does it show the reality of Rembrandt's position in those first years in Leiden?

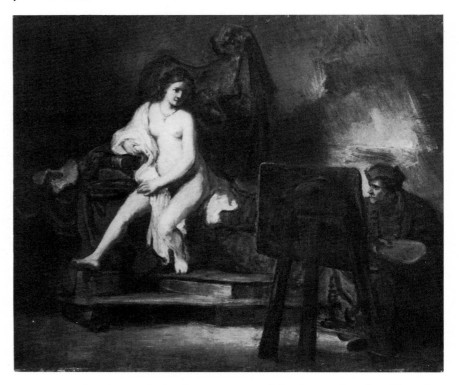

fig. 23 follower of REMBRANDT
Rembrandt (?) in his Studio with a Model
Glasgow, City Art Gallery and Museum.
Oil on panel 53 x 60.6 cm. Unsigned.
This painting, which is thought to be by a
follower of Rembrandt and which may
show Rembrandt working in his studio, is
generally dated in the 1640s.

Less obviously stark is the controversial picture in the City Art Gallery and Museum, Glasgow. The attribution to Rembrandt has been abandoned in recent years and even the possibility that it is Rembrandt himself painting the model has been denied. Nevertheless the picture gives an idea of a studio interior of the time, showing a figure very close in appearance to Rembrandt in the act of painting the model. These two unrelated pictures are scanty evidence indeed of how Rembrandt may have worked and our curiosity must rest at this point.

Surprisingly little has been written about Rembrandt's influence in general on later painters, perhaps because his vague shadows and brownish tonalities were easily imitated but never understood by mediocre painters. The precise influence of his self-portraits has been considered even less but it was far-reaching, especially on painters who lacked imagination. When most of the inventive or acutely observant painters of the eighteenth and early nineteenth centuries chose to depict themselves, like Chardin or David, they were not interested in Rembrandt. Predictably it was in England that Rembrandt's influence took a firm hold, as so many of his pictures were being imported in the eighteenth century, many of them through the agency of Sir Joshua Reynolds himself. His numerous self-portraits are derived from Rembrandt in tone, colouring and composition, without copying him

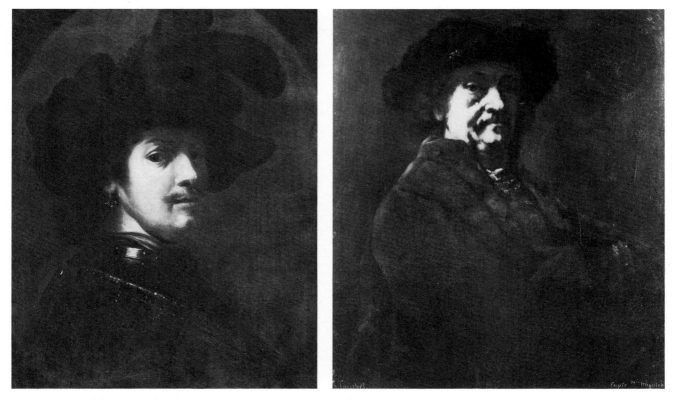

fig. 24 Thomas BARKER of Bath
Self-portrait in the Manner of Rembrandt
Bath, Holburne of Menstrie Museum.
Oil on canvas 57 x 44.5 cm. Unsigned.
Probably painted about 1800, this picture
is a virtual caricature of the *Self-portrait*
(Plate 49) in The Hague, and shows
Rembrandt's influence in England in the
late eighteenth and early nineteenth
centuries.

fig. 25 Gustave COURBET
Copy of a Self-portrait by Rembrandt
Besançon, Musée des Beaux-Arts. Oil on
canvas 87 x 73 cm. Signed and dated
lower left: 69 G. Courbet; annotated
lower right: Copie Mée Munich.

exactly. Reynolds in turn influenced the next generation of painters
and the result can be seen in the amusing picture by Thomas Barker of
Bath in the Holburne of Menstrie Museum at Bath. The result is a
caricature of The Hague *Self-portrait* (Plate 49) by Rembrandt, and it is
difficult to believe that Barker was both taken seriously and much
esteemed by the fashionable society of the time.

Rembrandt's influence on other painters in general had disappeared
by the middle of the nineteenth century, although he can be said to
have affected painters as different from one another as Fragonard, who
copied him, and Courbet, whose technique is often akin to Rembrandt's
late work, and who made a copy of a *Self-portrait* in the Alte Pina-
kothek, Munich, a work no longer considered to be by Rembrandt (see
Plate 78 for the original in Vienna).

It is difficult now to realize that Rembrandt flouted the conventions
of his contemporaries. The Amsterdam patrons of the 1660s preferred
their pictures to be minutely detailed and very carefully painted. Thus
they could admire the matter-of-fact approach of the infinitely pains-
taking Jan van der Heyden. By contrast Rembrandt allows the imagin-
ation to wander in a way never intended by any other Dutch painter.
This has meant that in the last hundred years Rembrandt has inspired
above all things the written word. His ravaged face has allowed the

[37]

creation of a dream world of tragedy more suitably confined to the pages of a book or the cinema screen. Quite simply he makes a good story. This story has been avoided here because it is the writer's belief that it cannot be deduced from looking at the pictures themselves.

But looking back at Rembrandt's self-portraits with a totally open mind what is the impression? A tired old man? A few brilliant strokes of a heavily laden brush? No. The effect is one of an observation so intense that it fills the room where the picture hangs. This applies to the Dresden *Self-portrait with Saskia* (Plate 59) just as much as it does to the *Self-portrait* of 1669 in The Hague (Plate 97). More than any painter who has ever lived, Rembrandt forced so much of himself on the canvas that he can still delight, intimidate, and above all move the corrupted sensibility of the twentieth century.

CATALOGUE

The history of each picture has been limited to the date when it was first recorded. The controversial aspects of modern scholarship have been indicated.

Height precedes width.

Notes on condition have on the whole been avoided because the available information is so inconsistent. A surprisingly large number of the signatures and the dates have been challenged at different times but in the absence of consistent and comprehensive information this issue has been avoided.

PAINTINGS

1 Self-portrait [Plate 8]
MUNICH, Alte Pinakothek. Oil on panel 15.5 x 12.7 cm. Signed in monogram and dated on the right on a level with the chin: RHL 1629.

First recorded in the nineteenth century in the Grand Ducal Gallery at Gotha, this picture was acquired by the museum in 1953 from the family collection of the dukes of Saxe-Coburg-Gotha. No copies are known.

2 Self-portrait [10]
KASSEL, Staatliche Gemäldegalerie. Generally dated after 1626. Oil on panel 23.5 x 17cm. Unsigned.

This picture, first recorded in the inventory of the landgrave Wilhelm VIII of Hesse-Kassel in 1749, is considered to be the earliest surviving self-portrait. It was described by Emile Michel in 1893 as indicating 'a young peasant, robust and naive'.

Several other copies are known. The two best ones are: (i) formerly in the Matsvansky collection, Vienna; (ii) formerly in the collection of Sir John Heathcote-Amory.

3 Self-portrait [11]
AMSTERDAM, Rijksmuseum. Generally dated after 1626. Oil on panel 22.6 x 18.7 cm. Unsigned.

This painting is considered, along with the Kassel picture (no. 2), to be the earliest surviving self-portrait. Considered to be an original by Bauch in 1966, the picture's recent acquisition by the Rijksmuseum is an indication of its improved status in recent years even though Gerson continued to describe it as a copy. The Kassel picture is generally favoured as the better version but there appears to be little difference between the two in terms of quality. Two copies are listed in the entry for no. 2.

4 A Portrait of Rembrandt (?) [12]
INDIANAPOLIS, Museum of Art (on loan from the Clowes Collection). The picture is of the type associated with the Leiden period, 1629-31. Oil on panel 43 x 33cm. Signed in monogram in lower right: RHL.

It was first recorded in the Lubomirsky collection, Lemberg (Lvov), in the early nineteenth century, although Hofstede de Groot noted that it could have been in the Locquet sale in Amsterdam in 1783 as lot 235, when it was bought by the dealer Yver for 350 florins. Gerson believed this picture to be an invention of Jan Lievens.

An amazing number of copies and variants of this picture exists: (i) sale Robert and others, Cologne, 27 March 1893, lot 232; (ii) Paris, E. Warneck collection, 1915; (iii) sale, Vienna, St Saphorin, 19 May 1806, lot 11; (iv) Russia, Gatschina Palace; (v) sale Bukowski, Stockholm, 1954; (vi) Brussels, collection of Count Cavens, 1930s; (vii) Talon sale, Brussels, 10 March 1927, lot 85; (viii) sale Fischer, Lucerne, 20 October 1941, lot 1370; (ix) with Duits, London, exhibited at Nottingham, September 1945; (x) collection of Hubert Sternberg, Berlin, c. 1925. Several other copies exist, some of them in reverse, but these tend to be of even more mediocre quality.

5 Self-portrait (?) [13]
AMSTERDAM, Rijksmuseum. Painted during the Leiden period, 1629-31. Oil on panel 41.2 x 33.8 cm. Signed in monogram top right: RHL.

Unknown until the late nineteenth century when it appeared in the Esterhazy collection, Nordkirchen, this picture was in the collection of F. Stoop, Byfleet, Surrey for a long time. Gerson doubted this picture was a self-portrait. The sitter's features are so distorted that it appears like some older man with a superficial likeness to Rembrandt himself.

Several copies are known: (i) formerly in the collection of Sir Charles Robinson, London, then with Sedelmeyer, Paris, 1898, and afterwards in the Heugel collection in Paris and then sold Brussels, Trussaert, 19 November 1956, lot 28 – this picture has occasionally been confused with the original; (ii) sale Fischer, Lucerne, 30 August-4 September 1937, lot 1660; (iii) in the collection of Prof. Dr L. Ruzicka, Zurich, 1939.

6 Self-portrait [14]
THE HAGUE, Mauritshuis. Generally dated late 1620s. Oil on panel 37.7 x 28.9 cm. Unsigned.

This picture was first recorded in the Govert van Slingelandt collection, The Hague, in 1752 (see also no. 22). Although unsigned, this is the best known of all the self-portraits dating from the Leiden period.

At least five copies are known: (i) recorded by Hofstede de Groot in the collection of Dr Abraham Bredius, The Hague; (ii) Copenhagen, Statens for Kunst (cat. 1909 no. 391); (iii) Nuremberg, Germanisches Nationalmuseum, which has recently been described as from Rembrandt's studio; (iv) Northwick sale, London, Sotheby's, 28 May 1918, lot 389, £430; (v) Count Attems, Graz, 1950; and then on the Zurich art market, 1952.

7 Self-portrait [15]
NEW YORK, private collection. Generally dated late 1620s. Oil on panel 61 x 47 cm. Unsigned.

This picture was first recorded when exhibited at the

Royal Academy, London, in 1899. Hofstede de Groot noted that a copy was in the possession of an English dealer in 1914; this may be the picture noted by Gerson which was sold at Sotheby's on 21 June 1950 as lot 76, although Gerson regarded it as a copy and presumably the one recorded in 1914. Few people have seen this picture and Gerson was surely right when he said 'It would seem wiser not to offer any final comments on its autograph character'. Its recent reappearance has affirmed, however, that it is likely to be from Rembrandt's hand.

8 Self-portrait [16]
CAMBRIDGE, Massachusetts, Fogg Art Museum (James P. Warburg bequest). Oil on panel 21 x 17 cm. Signed with monogram and dated centre right: RHL 1629.
First published by W. R. Valentiner in 1925, this picture's authenticity was doubted by Gerson who was 'not fully convinced'. From the photograph, the picture appears weak, but it has to be remembered that at this stage in his career Rembrandt was not a consistently accomplished painter.

9 Self-portrait [17]
THE HAGUE, with Cramer, formerly Aerdenhout, Louden collection. Oil on panel 49 x 39 cm. Signed in monogram and dated on the left on a level with the chin: RHL 1630.
According to Hofstede de Groot this picture was possibly in the A. Grill sale in Amsterdam on 10 April 1776 as lot 31. It was first certainly recorded in the collection of count Julius Andrassy in Budapest in the mid-nineteenth century, and was later in the Museum of Fine Arts, Budapest. Jacob Rosenberg remarked on this picture 'No-one, in looking at this uncouth young man, would dare to predict the tremendous range of his future development'.

10 Self-portrait [18]
NEW YORK, Metropolitan Museum of Art (bequest of Evander B. Schley). Generally dated in the Leiden period, 1629-31. Oil on panel 22 x 16.5 cm. Signed in monogram on the right: RHL.
First recorded in the collection of Leopold II, King of the Belgians, in the nineteenth century, this picture's authenticity was doubted by Gerson, who said 'I am not convinced that the attribution to the young Rembrandt is correct'. The museum now considers the picture to be later in origin than Rembrandt's lifetime.

11 Self-portrait [19]
STOCKHOLM, Nationalmuseum. Oil on copper 15 x 12 cm. Remains of a signature and dated upper left: R. . . 1630 (?)
First recorded in a Rotterdam sale in 1768, when it changed hands for thirty-five florins, this is the only example of a Rembrandt self-portrait painted on copper, a support favoured by many Dutch artists, especially for small paintings.

12 Self-portrait [20]
BOSTON, Isabella Stewart Gardner Museum. Oil on panel 89 x 73.5 cm. Signed in monogram and dated right centre: RHL 1629.
This picture was first recorded in the collection of the Duke of Buckingham at Stowe, Buckinghamshire, in 1836, and was later in the famous Art Treasures exhibition held at Manchester in 1857.

13 Self-portrait [21]
LIVERPOOL, Walker Art Gallery. If the provenance of this picture is correct (see page 129), it must have been painted in 1629 or earlier. Panel 72.3 x 57.7 cm. Signed upper left: Rembrandt f (now considered to be a much later addition).
The picture was possibly given to Lord Ancram by the Stadhouder Frederik Hendrik in 1629. Not certainly recorded until 1840 at Penshurst Place, Kent, and then in the sale of Lord de L'Isle and Dudley at Christie's in London on 14 April 1948 as lot 144.
Many copies are known: (i) Ten Cate collection, The Netherlands; (ii) sale Fischer, Lucerne, 5 November 1955, lot 2130; (iii) Delaroff collection; (iv) Dresden-Hamburg art market 1925-35); (v) collection of Baroness Greindl, Brussels, 1961; (vi) an oval version was in the sale of Lord Brownlow in London at Christie's on 3 May 1929 as lot 30, and reappeared at Bukowski, Stockholm, in 1969; (vii) Private collection, Italy, 1970; (viii) another oval version, whereabouts unknown (photograph in the Rijksbureau voor Kunsthistorische Documentatie in The Hague).

14 Self-portrait [22]
FLORENCE, Galleria degli Uffizi. Generally dated 1634, but likely to be c. 1630. Oil on panel 62 x 52 cm. Signed on the left: . . .f.
This painting first appeared in the collection of the Marchese Gerini in Florence c. 1724, and has been cut both at the sides and the top, thus leaving only the 'f' of the signature. A strip some 12 cm. wide has been added at the bottom. Gerson stated that the cloak was over-painted, perhaps in the eighteenth century, and described the picture as 'weaker than the undoubted self-portraits of the period'.
Several copies are known: (i) Spencer Churchill sale, Christie's, London, 25 February 1966, lot 31; (ii) collection of F. Clarke, Norwood; (iii) Private collection, Paris, 1932; (iv) Glasgow, City Art Gallery and Museum (thought to be early nineteenth century). Several other versions of varying quality, their present whereabouts unknown, are recorded in the files of the Rijksbureau voor Kunsthistorische Documentatie, The Hague.

15 Self-portrait with a Dog [37]
PARIS, Musée du Petit Palais. Oil on panel 65 x 52 cm. Signed and dated lower right: Rembrandt F. 1631.
The earliest record of this picture was in the Schamp d'Aveschot sale at Ghent in 1840. Gerson regards it as being 'by one of Rembrandt's followers'. It certainly represents Rembrandt and it may be the unusual approach to the subject which has led people to doubt the work.
Two copies are known: (i) Vienne (Isère) Musée; (ii) exhibited at Knokke-le-Zoute, *Autour de Rembrandt*, 1969.

16 Self-portrait [38]
SWITZERLAND, Private collection. Oil on panel 70.8 x 50.2 cm. Unsigned.
This picture was first recorded in the collection of Madame Lerouge in Paris in 1818. Because it has not been seen for many years, it has tended to disappear from the literature. Comment on its autograph status is not at present possible.
(i) A copy was with F. Muller of Hamburg about 1935.

17 Self-portrait [39]
EINDHOVEN, Philips collection. This painting, if authentic, was probably painted in the early 1630s. Oil on panel 20 x 17 cm. Unsigned.

First recorded in the eighteenth century when it was in the collection of the dukes of Argyll, this picture is believed by Gerson 'neither to be by Rembrandt, nor from his period'.

(i) A copy was in the Evers collection, Arnhem, in 1938.

18 Self-portrait [40]
GLASGOW, Burrell Collection. Oil on panel 63 x 47 cm. Signed and dated centre right: RHL van Ryn 1632.

This picture was first recorded in the comtesse de la Verrue sale in Paris on 27 March 1737 as lot 14, when it made 450 francs with a pendant.

A large number of copies of this striking picture are known: (i) present whereabouts unknown, formerly Gotha Museum, Gotha; (ii) Stockholm, Lind collection; (iii) Le Mans, Musée de Tessé; (iv) Minden, Jos. Schmitz; (v) Warsaw, National Museum. Hofstede de Groot noted that there were 'others repeatedly in the possession of dealers' and at least half a dozen are recorded in the files of the Rijksbureau voor Kunsthistorische Documentatie in The Hague.

19 Self-portrait [44]
PARIS, Musée du Louvre. Oil on panel 60 x 47 cm. Signed and dated on the right below the centre: Rembrandt f. 1633.

First mentioned in the Musée Napoleon in Paris in the early nineteenth century, this painting was valued by the experts in 1816 at 8000 francs.

Two copies are known: (i) with Armand Rodde, Asnières, 1938; (ii) a variant at Montpellier, Musée Fabre.

20 Self-portrait [45]
PARIS, Musée du Louvre. Oil on panel 70 x 53 cm. Signed and dated on the right below the centre: Rembrandt f. 1633.

This painting was recorded for the first time in the duc de Choiseul sale in Paris on 6 April 1772. Fromentin wrote a beautiful passage on Rembrandt's self-portraits, and from the description either this picture, or the one very similar to it, which is also in the Louvre (see no. 19, Plate 44), was the picture which inspired him. 'He (Rembrandt) turned up his moustache, put air and some play into his curling hair; he smiled with strong red lips, and his little eye, almost lost in the projecting eyebrow, darted a peculiar glance in which there was fire, steadiness, insolence and contentment'.

Several copies are known. The best ones are: (i) sale, New York, Parke-Bernet, 20 October 1954, lot 28; (ii) collection Dr Wydler-Orendi, Zurich, 1954.

21 Self-portrait [46]
BERLIN-DAHLEM, Staatliche Gemäldegalerie. Oil on panel 58.3 x 47.5 cm. Signed and dated lower right on a level with the shoulder: Rembrandt f. 1634.

This picture was first recorded at Sans Souci, Potsdam, in the collection of Frederick the Great of Prussia in 1764 (see also no. 25). In 1893 Emile Michel regarded this as Rembrandt's most gracious self-portrait. Rosenberg perceptively noted that this unusually elegant picture 'can almost rival a Van Dyck'.

(i) a copy has been in the Staatliche Museum, Schwerin, since at least 1821.

22 Self-portrait [49]
THE HAGUE, Mauritshuis. Probably painted in the mid-1630s. Oil on panel 62.9 x 46.8 cm. Signed on the right on a level with the shoulder: Rembrandt. f.

This painting was first mentioned in the collection of Govert van Slingelandt, The Hague, in 1752 (see also no. 6). The unusual pose and garb have led some scholars, notably Bauch, to question the identification as a self-portrait.

Five copies of this picture are known: (i) Stockholm, Nationalmuseum; (ii) a copy by Thomas Barker of Bath, in the Holburne of Menstrie Museum at Bath (fig. 24); (iii) Elberfeld, Mischel collection (in 1900); (iv) Coblenz, art market (1950); (v) San Francisco, Russel Hartley collection. There is also a drawing by Fragonard after this picture, or a copy of it.

23 Self-portrait [50]
KASSEL, Staatliche Gemäldegalerie. Oil on panel 79 x 64 cm. Signed and dated on the right above the shoulder: Rembrandt f. 1634.

In the early part of the eighteenth century this picture was in the collection of Valerius de Reuver of Delft and was first recorded when he acquired it at the sale of Gerard Gueree in Delft in 1728. It was documented in 1749 in the inventory of pictures belonging to landgrave Wilhelm VIII of Hesse-Kassel (see also no. 2). Gerson was not certain that the painting was by Rembrandt and noted that 'an attribution to Govert Flinck should be considered'.

(i) A version or copy, signed and dated 1633, was in the E. Schwerdt sale in New York on 25 April 1928 as lot 56 (Smith 226). See fig. 4 for a derivation of this picture.

24 Self-portrait [51]
Formerly VADUZ, collection of the Prince of Liechtenstein. Oil on panel 92 x 72 cm. Signed and dated: Rembrandt f: 1635.

The earliest record of the picture seems to be 1885 when the picture was catalogued while in Vienna. Gerson considered the picture to be 'close to . . . Govert Flinck'. From the photograph, the picture appears to be of high quality. The painting left the Liechtenstein collection some fifty years ago. Its present location is unknown.

The following copies are known: (i) Wiesbaden Museum; (ii) Rome, Galleria Nazionale: according to Hofstede de Groot in this copy there are no feathers in Rembrandt's cap; (iii) Cook sale, Sotheby's, London, 25 June 1958, lot 113, as by Rembrandt himself and signed and dated 1638.

25 Self-portrait [52]
BERLIN-DAHLEM, Staatliche Gemäldegalerie. Generally dated c. 1633-34. Oil on panel 56 x 47 cm. Unsigned.

This picture was first recorded in the picture gallery of Frederick the Great at Sans Souci, Potsdam, in 1786 (see also no. 21).

26 Self-portrait [56]
PARIS, Musée du Louvre. Oil on panel 80 x 62 cm. Signed and dated lower right: Rembrandt f. 1637.

The first record of this painting is in the collection of Louis XVI of France who acquired it in 1785. It is doubted by Gerson who noted that until the picture were cleaned it seemed 'wiser to withhold final judgement as to its authenticity, even though in its present condition an attribution to Flinck seems to me to be reasonable'. The picture is certainly quite close in style and com-

position to the *Portrait of Rembrandt* in Glasgow (see fig. 6), now generally thought to be by Flinck, but it may well be that the Louvre picture is the prototype which Flinck imitated.

(i) A copy was sold twice at Christie's in 1949 (15 July, lot 22 and 14 October, lot 127).

27 Self-portrait [57]
LONDON, Wallace Collection. Probably painted in the mid-1630s. Oil on panel 65 x 51 cm. Signed on the right above the arm: Rembrandt ft.

Possibly first recorded in the Gerard Hoet sale in The Hague on 25 August 1760 as lot 48, this painting was certainly recorded in the sale of comte F. de Robiano in Brussels on 1 May 1837 where it was sold for 5500 francs. Gerson described the picture as being rather dull in execution.

(i) A copy was in the Hamilton Palace sale in London on 17 June 1882, according to Hofstede de Groot, and then in the E. R. Thomson collection in New York.

28 Self-portrait [58]
SAO PAULO, Museu de Arte. Probably painted in the mid-1630s. Oil on panel 57.5 x 44 cm. Signed halfway up on the right: Rembrandt.

This painting appeared for the first time in the nineteenth century in the collection of Lord Palmerston at Broadlands, Hampshire. Gerson noted that 'The attribution to Rembrandt is not wholly convincing'. He also doubted that it was a self-portrait.

(i) A copy of the head was on the Amsterdam art market in the 1960s and several other versions have appeared, most of them very inferior.

29 Self-portrait with Saskia [59]
DRESDEN, Staatliche Gemäldegalerie. Generally dated 1634. Oil on canvas 161 x 131 cm. Signed halfway up on the left: Rembrandt f.

This painting was first recorded in the Araignan sale in Paris in 1751. Although this is not strictly a self-portrait, Rembrandt recorded his own features in a way which has led most of the earlier writers to treat the picture as such. In 1893 Emile Michel wrote a long passage in praise of the picture, and was very moved by the contrast between the twenty-two year old Saskia and the greater assurance and maturity of Rembrandt himself. The most common modern interpretation is that it represents the *Prodigal Son in a tavern*.

30 Self-portrait with a Dead Bittern [63]
DRESDEN, Staatliche Gemäldegalerie. Oil on panel 121 x 89 cm. Signed and dated on the beam above to the left: Rembrandt fc. 1639.

This painting was first recorded in the Dresden collection at the time of the inventory made by Guariento in 1751. Emile Michel praised the picture's tonal harmony, but did not realize that it was a self-portrait.

Several copies are known, all of them very inferior. The two better ones are: (i) sold Berlin, 5 May 1914, lot 62; (ii) sale Mrs H. O. Havemeyer, New York, Anderson Galleries, 10 April 1930, lot 102.

31 Self-portrait [64]
PASADENA, California, Norton Simon Foundation. Oil on panel 62.5 x 50.6 cm. Signed and dated centre right: Rembrandt f. 163[?] (the last digit has been thought to be '9'. This would certainly make sense on grounds of style).

This picture first appeared in the sale of the Earl of Portarlington in London on 28 June 1879.

(i) A copy was on the art market in Amsterdam and Berlin in the early part of this century, and several inferior derivations are recorded in the files of the Rijksbureau voor Kunsthistorische Documentatie in The Hague.

32 Self-portrait [65]
LONDON, National Gallery. Oil on canvas 102 x 80 cm. Signed and dated on the sill on the right: Rembrandt f. 1640 conterfeycel.

The painting was first recorded in the mid-nineteenth century when in the collection of General Dupont in Paris, but the incription is thought to have been added by a later hand. In 1893 Emile Michel described the execution as a little cold and minutely detailed; obviously the picture did not appeal at that time. Rosenberg saw in the picture the first suggestion of an inner emotional crisis.

33 Self-portrait [66]
WOBURN ABBEY, Collection of the Marquess of Tavistock. Oil on panel 87.5 x 72.5 cm. Signed: Rembra. . .

This picture, which reflects the style of the late 1630s, was first recorded at Woburn Abbey in 1748 when acquired from the Bragge sale. John Smith described the picture in 1836 but made no remark as to its quality, while Gerson described the picture as 'too weak to be an original Rembrandt'. A comparison with the other version, in Ottawa (see next entry) is inconclusive as to which is superior. Whether either or both are by Rembrandt is still an open question.

34 Self-portrait [67]
OTTAWA, National Gallery of Canada. Oil on canvas 94 x 74.9 cm. Unsigned.

This picture, which reflects the style of the 1630s, was first recorded in the collection of the Earl of Listowel in the nineteenth century. The relationship between this picture and the version at Woburn Abbey (see no. 33) seems never to have been properly studied. The slight differences between the two pictures imply that neither one is a copy of the other. The gallery regards the picture as being by a follower of Rembrandt.

35 Self-portrait [68]
LUGANO, Baron Thyssen collection. Oil on panel 71 x 57 cm. Unsigned.

The picture seems to have been first recorded in 1851, when it was engraved as in the von Leuchtenberg collection, St Petersburg. Gerson regarded the attribution both to Rembrandt and to his period as doubtful. A careful examination of the picture reveals Gerson's judgement to be too severe: the picture should be reinstated as a Rembrandt.

36 Self-portrait [69]
WINDSOR CASTLE, Royal Collection (Reproduced by gracious permission of Her Majesty The Queen). Oil on panel 70.5 x 58 cm. Signed and dated to the right on the level with the shoulder: Rembrandt f. 164[?] (the last digit is generally interpreted as a '7').

Possibly in an anonymous sale in Amsterdam on 6 October 1801 as lot 55, this picture was first certainly recorded in 1814 when bought by the Prince Regent, later George IV, from the Baring collection. The picture has not been restored in recent years and suffers from overpainting, some of which may well have been done by Rembrandt himself. The Royal Collection does not now consider this picture to be by Rembrandt.

37 Self-portrait [72]
KARLSRUHE, Staatliche Kunsthalle. Generally dated in the late 1640s. Oil on panel 69 x 56 cm. Signed right background: Re . . .

First recorded in 1703 when in the collection of the French painter Hyacinthe Rigaud. X rays have revealed that the picture is painted over a portrait of an old man.

Three copies are known and there is some confusion between them: (i) Gaunø, Denmark, baron Reedz Thott; (ii) sale Lepke, Berlin, 10 December 1907, lot 76; (iii) on the Zurich art market in 1951. There are several others, all of inferior quality, recorded in the files of the Rijksbureau voor Kunsthistorische Documentatie in The Hague.

38 Self-portrait [73]
WASHINGTON, National Gallery of Art (Widener collection). Oil on canvas 92 x 75.5 cm. Signed and dated on the right above the hand: Rembrandt f. 1650.

This picture appeared for the first time in the sale of Sébastien Erard in Paris on 23 April 1832 as lot 119. John Smith in 1836 noted that the old identification of Admiral van Tromp was not accurate, and that the sitter appeared very much more like Rembrandt himself. Smith then went on to add 'The face is partly in shadow, beautifully varied by reflex lights, and the head is opposed to a light brown back-ground. This superlative example of portraiture is dated 1651'. Gerson was curiously severe about this picture and remarked that 'the signature is not genuine and the portrait is an eighteenth- or nineteenth-century imitation, combining light effects typical of Rembrandt's early work with a composition and mood characteristic of the later period'.

39 Self-portrait [76]
VIENNA, Kunsthistorisches Museum. Oil on canvas 112 x 81.5 cm. Signed and dated bottom left: . . .dt f. 1652.

This picture was first mentioned when in the collection of the Emperor Charles VI who reigned 1711-42. John Smith remarked in 1836 that the picture 'possessed extraordinary vigour both in execution and effect'.

The following copies are known: (i) London, Wallace Collection; (ii) Gateshead, Shipley Art Gallery; (iii) Bust only, exhibited at Bregenz in 1966; (iv) collection of Dr J. P. Sypkens, Toronto and Groningen, 1960; (v) formerly (?) Vaduz, collection of the Prince of Lichtenstein. Several others, mostly of very inferior quality, are recorded in the files of the Rijksbureau voor Kunsthistorische Documentatie in The Hague.

40 Self-portrait [77]
KASSEL, Staatliche Gemäldegalerie. Oil on canvas 73 x 59 cm. Signed and dated right centre: Rembrandt f. 1654 (possibly 5).

This painting appeared for the first time in the de Reuver collection, Delft, in 1709. Gerson noted that 'the attribution to Rembrandt is not wholly convincing'.

(i) There is one known copy in the Musée du Louvre, Paris.

41 Self-portrait [78]
VIENNA, Kunsthistorisches Museum. Oil on panel 63 x 53 cm. Signed and dated upper left: Rembrandt f. 1655.

This painting was first recorded in the sale of Lord Carysfort in London on 14 June 1828. In 1836 John Smith described the picture as 'painted in a free and bravura manner'.

(i) A related version in the Alte Pinakothek, Munich, was itself copied by Gustave Courbet (fig. 25) in the nineteenth century. It is no longer considered to be authentic, even though it was first recorded as early as 1719.

42 Self-portrait [79]
FLORENCE, Galleria degli Uffizi. Probably painted in the 1650s. Oil on canvas 71.5 x 57.5 cm. Unsigned.

One of the two self-portraits recorded in the Uffizi by Baldinucci in 1686. Gerson remarked: 'according to Slive, a copy. It is difficult to judge through the dark varnish but Slive is certainly right'.

43 Self-portrait [80]
DRESDEN, Staatliche Gemäldegalerie. Oil on canvas 85.5 x 65 cm. Signed and dated on the foot of the book: Rembrandt f. 1657.

First mentioned in the Dresden inventory of 1722, this picture is regarded by most authorities, with the exception of Hofstede de Groot, as the best of the four versions now known. The picture's authenticity was questioned by Rosenberg.

The other versions are: (i) San Francisco, M. H. de Young Memorial Museum (see next entry); (ii) Rousham House, Oxfordshire, C. Cottrell-Dormer (fig.17) (described by Gerson as not an original); (iii) United States of America, Private collection, formerly London art market.

44 Self-portrait [81]
SAN FRANCISCO, M. H. de Young Memorial Museum (The Roscoe and Margaret Oakes Foundation). Oil on canvas 74.5 x 61 cm. Signed and dated: . . . brandt 1653.

The picture first appeared in the late nineteenth century in the collection of Edward Lindley Wood at Temple Newsam House, Leeds, and was described by Gerson as 'of unimpressive quality'. Hofstede de Groot had already stated that he believed it to be a copy. It is certainly inferior to the Dresden picture but this is not in itself proof that it is not by Rembrandt. On grounds of style the picture is so close to the Dresden composition that the final digit of the date ought to be a 7 rather than a 3. The Museum believes the picture to be by an imitator of Rembrandt.

45 Self-portrait [82]
EDINBURGH, National Gallery of Scotland (lent by the Earl of Ellesmere). Oil on canvas 53.5 x 44 cm. Signed and dated right background: Rembrandt f. 1659.

First recorded in the sale of the Countess of Holderness in London on 6 March 1802 as lot 56, this picture was bought by Lord Gower for £81 18s. In 1836 John Smith valued the picture at £300 and described it as '. . . painted in a fine style, and is so like reality, as to be almost deceptive'. At that time the picture was rather larger than it is now, additions on all four sides having been removed in a restoration carried out in 1933 by Dr A. M. de Wild. This may well turn out to have been a mistake.

46 Self-portrait [83]
VIENNA, Kunsthistorisches Museum. Probably painted in the late 1650s. Oil on panel 49 x 41 cm. Signed top left: Rembrandt f.

As it was first recorded in the Imperial Gallery in Vienna in 1783, this picture was therefore probably

acquired by Joseph II. Described by John Smith in 1836 as a 'fine example' of the master.

(i) A nineteenth-century copy is in a Private collection in Bergen, Norway, as by the Norwegian painter Sigwald Dahl. (ii) A reduced replica, with slight differences in the costume, is in the Liechtenstein collection, Vaduz.

47 Self-portrait [87]

NEW YORK, Frick Collection. Oil on canvas 133.7 x 103.8 cm. Signed and dated on the knob of the chair: Rembrandt f. 1658.

This picture was first mentioned in 1815 in the collection of the Earl of Ilchester at Melbury Park, Dorset, when it was loaned by him to the British Institution. It was acquired by Henry Clay Frick in 1906.

48 Self-portrait [88]

WASHINGTON, National Gallery, Andrew W. Mellon collection. Oil on canvas 84.1 x 66 cm. Signed and dated to the left on a level with the shoulder: Rembrandt f. 1659.

This painting first appeared in the collection of George, Duke of Montague, who died in 1790.

49 Self-portrait [89]

PARIS, Musée du Louvre. Oil on canvas 111 x 90 cm. Signed and dated lower right: Rem. . . f. 1660.

This self-portrait was first recorded in the collection of Louis XIV, Le Brun Inventory, Paris, in 1690/91 as no. 318. Hofstede de Groot regarded the signature and date as being by a later hand, while Jacques Foucart believed it to have been retouched. A strip of canvas just over 5 cm. wide has been added at the right. Fromentin devoted a delightful passage to this picture: 'Later, after his mature years, in his days of difficulty, we see him appear in graver, more modest, more veracious garb; without gold, without velvet, in dark garments with a handkerchief around his head, his face saddened, wrinkled, emaciated, his palette in his rugged hands. This garb of disillusion was a form that the man took when he was upwards of 50 years of age, but it only complicated still further the true idea one would like to form of him.'

Several copies are known: (i) sale Herren Schward of Berne, Paris, 24 January 1810; (ii) the head only, collection of M. C. D. Borden, New York (Smith 229); (iii) by Adolfe-Felix Cals, formerly Doria collection; (iv) by Fantin-Latour, Lyons, Musée des Beaux-Arts.

50 Self-portrait [90]

NEW YORK, Metropolitan Museum of Art (bequest of Benjamin Altman). Oil on canvas 80.5 x 67.3 cm. Signed and dated lower right: Rembrandt f. 1660.

First recorded in the collection of the duc de Valentinois, Paris, in the late eighteenth century, this picture was described by John Smith in 1836 as 'very excellent'.

51 Self-portrait [91]

LONDON, Kenwood House, Iveagh Bequest. Generally dated about 1660 but could be later, perhaps 1667/8. Oil on canvas 114.3 x 94 cm. Unsigned.

This painting appeared for the first time in the sale of the comte de Vence in Paris on 11 February 1761, where it made 481 francs. John Smith was obviously impressed with this picture and remarked that 'Rembrandt's animated expression indicates him to be engaged at his studies in his atelier, on the walls of which are described some geometrical figures'.

(i) A copy is in the Musée Granet, Aix-en-Provence (still attributed there to Fragonard), and the picture was drawn by Fragonard when it was still in the Vence collection in Paris, in other words before 1761. (ii) The same composition showing head and shoulders only is in the Prado, Madrid. Its date is indeterminate.

52 Self-portrait [92]

MELBOURNE, National Gallery of Victoria (Felton bequest). Oil on canvas 76.8 x 60.9 cm. Signed and dated on the right: Rembrandt f. 1660.

This painting was first mentioned as being in the Bulstrode collection in 1809 at the time of its acquisition by the Duke of Portland for his collection at Welbeck Abbey, Nottinghamshire. Gerson remarked that 'I know the painting only from photographs, which do not give a favourable impression'.

(i) A replica (HdG. 561) was in the Baroness Cassel van Doorn sale in Paris, at Charpentier, on 30 May 1956 as lot 44, having previously been in the collection of the Marquess of Lothian at Newbattle Abbey, Scotland.

53 Self-portrait [93]

CAMBRIDGE (MASSACHUSETTS), Fogg Art Museum. Probably painted about 1660. Oil on canvas 72.9 x 65.6 cm. Unsigned.

Roger Fry first published the picture in *The Burlington Magazine,* in May 1921. Formerly in the collection of S. Bronfman, Montreal. Gerson doubted the picture by saying 'the attribution to Rembrandt does not seem to be certain'.

54 Self-portrait [84]

AIX-EN-PROVENCE, Musée Granet. Probably painted in the early 1660s. Oil on panel 30 x 24 cm. Unsigned.

The first record of this picture is when it was bequeathed by the son of J. B. M. Bourguignon de Fabrigoules to the museum in 1863. Rosenberg remarked that the picture 'has all the boldness and immediacy of a Goya', and considered it to be a study for a larger life-sized portrait. Gerson was very scathing of this masterpiece when he said 'I can only see in this sketchy portrait an imitation after Rembrandt'. It is now doubted by most authorities, although the reasons for this are obscure.

55 Self-portrait as the Apostle Paul [94]

AMSTERDAM, Rijksmuseum. Oil on canvas 91 x 77 cm. Signed and dated left, on a level with the shoulder: Rembrandt f. 1661.

Initially recorded at an unknown date when in the Fournier collection, this picture was certainly brought to England in 1807 from the Corsini Palace, Rome, by William Buchanan. The picture was described (twice) by Smith who did not comment on its quality.

Two decent copies are known: (i) Riga, National Museum of Fine Arts; (ii) sale Hahn, Frankfurt, 5/6 April 1936, lot 134, and many others of inferior quality are recorded in the files of the Rijksbureau voor Kunsthistorische Documentatie in The Hague.

56 Self-portrait [95]

FLORENCE, Galleria degli Uffizi. Probably painted in the mid-1660s. Oil on canvas 85 x 61 cm. Unsigned.

One of the two pictures by Rembrandt mentioned by Baldinucci in the Uffizi in 1686.

Several copies are known: (i) Naples, Museo di Capodimonte; (ii) in the Clerk collection, Penicuik (Scotland), described in the 1750 inventory as 'The

Head of the painter Rynbrandt – a copy by my Br Sandie'; (iii) with F. H. Clarke, London, 1926; (iv) by Fra Vittorio Ghislandi, formerly Dresden, Gemäldegalerie, acquired in 1742 and destroyed during the last war. Many others of very inferior quality are in the files of the Rijksbureau voor Kunsthistorische Documentatie in The Hague.

57 Self-portrait [96]
LONDON, National Gallery. Oil on canvas 86 x 70.5 cm. Remains of signature and date at left: . . .t (?) f. 1669.

This picture was first recorded in the collection of William van Huls as lot 22 in his sale in London on 6 August 1722.

Four copies are recorded: (i) collection of E. M. H. Os, The Hague, 1941; (ii) P.Smith, Colchester; (iii) collection of M. de Rees, Cannes; (iv) art market, The Hague, 1940.

58 Self-portrait [97]
THE HAGUE, Mauritshuis. Oil on canvas 63.5 x 57.8 cm. Signed and dated: Rembrandt f. 1669.

This picture was first mentioned in the collection of Sir Joseph Neeld, Bart, before 1850, in London. It was later at Grittleton House, Wiltshire, in the nineteenth century. Rosenberg expressed a certain disappointment with his touching picture: 'We detect some decline in the aged artist's expressive power. His painterly skill has not failed him, but the psychological content shows a diminished intensity'.

59 Self-portrait (as the Laughing Philosopher) (fragment) [98]
COLOGNE, Wallraf-Richartz Museum. Probably painted as late as 1669. Oil on canvas 82.5 x 65 cm. Unsigned.

This picture first appeared in the collection of Sir Culling Eardley, Bart., of Belvedere House, Erith, Kent, in 1761. It is quite likely that in Smith's time (1836) the picture was a good deal less dark than it is now. Smith remarked that Rembrandt 'appears to be still engaged in the study of his art, as a portion of the mahlstick is seen at the side, although the hand which holds it is not visible; a bust is placed on his right. Painted in a broad free manner'.

DRAWINGS

1 : c.1628 *Self-portrait* [Plate 6]
Muri-Berne, J. de Bruijn Collection.
12.7 x 9.5 cm.

2 : c.1629 *Self-portrait* [7]
London, British Museum. 12.6 x 9.5 cm.

3 : 1630 *Self-portrait* [24]
Paris, Louvre. 8.1 x 9.2 cm.

4 : 1631 *Self-portrait in a soft hat* [36]
completion of B7 (Plate 23) in black chalk.
London, British Museum. 14.6 x 13.0 cm.

5 : c.1633 *Self-portrait* [43]
Marseilles, Musée des Beaux-Arts.
11 x 11 cm.

6 : c.1635 *Self-portrait* [53]
Berlin, Kupferstichkabinett. 12.5 x 13.5 cm.

7 : c.1635 *Self-portrait* [54]
New York, Metropolitan Museum of Art
(Robert Lehman collection) 14.5 x 12.1 cm.

8 : c.1639 *Self-portrait* [62]
Washington, National Gallery
(Lessing J. Rosenwald collection).
12.8 x 12.2 cm.

9 : c.1655 *Self-portrait in studio attire* [75]
Amsterdam, Rembrandthuis.
20.3 x 13.4 cm.

10 : c.1658 *Self-portrait* [86]
Rotterdam, Koenigs Collection, Museum
Boymans – van Beuningen. 6.9 x 6.2 cm.

11 : c.1660 *Self-portrait* [85]
Vienna, Albertina. 8.4. x 7.1. cm.

ETCHINGS

1 :	c.1628	B4	*Self-portrait with a broad nose* [Plate 1]
2 :	c.1628	B5	*Self-portrait leaning forward* [2]
3 :	c.1628	B9	*Self-portrait leaning forward* [3]
4 :	c.1628	B27	*Self-portrait bare-headed* [4]
5 :	1629	B338	*Self-portrait bare-headed* [9]
6 :	1629-31	B12	*Self-portrait in a fur cap in an oval* [5]
7 :	1630	B13	*Self-portrait open-mouthed* [25]
8 :	1630	B24	*Self-portrait in a fur cap* [26]
9 :	1630	B174	*Self-portrait as a beggar seated on a bank* [27]
10 :	1630	B316	*Self-portrait in a cap* [28]
11 :	1630	B320	*Self-portrait in a cap, eyes wide open* [29]
12 :	c.1630	B1	*Self-portrait with curly hair and a white collar* [30]
13 :	1630	B10	*Self-portrait frowning* [31]
14 :	1631	B7	*Self-portrait in a soft hat and embroidered cloak* [23]
15 :	1631	B15	*Self-portrait in a cloak with a falling collar* [32]
16 :	1631	B16	*Self-portrait in a heavy fur cap* [33]
17 :	c.1631	B8	*Self-portrait with long bushy hair* [34]
18 :	c.1631	B319	*Self-portrait with cap pulled forward* [35]
19 :	c.1632	B363	*Sheet of studies with the head of the artist* [41]
20 :	1633	B17	*Self-portrait in a cap and scarf* [42]
21 :	1634	B18	*Self-portrait with a raised sabre* [48]
22 :	c.1634	B2	*Self-portrait wearing a soft cap* [47]
23 :	1636	B19	*Self-portrait with Saskia* [55]
24 :	1638	B20	*Self-portrait in a velvet cap with a plume* [60]
25 :	1639	B21	*Self-portrait leaning on a stone sill* [61]
26 :	1642	B26	*Self-portrait in a flat cap and embroidered dress* [70]
27 :	1648	B22	*Self-portrait drawing at a window* [71]
28 :	1651	B370	*Sheet of studies with the head of the artist* [74]

THE SELF PORTRAITS

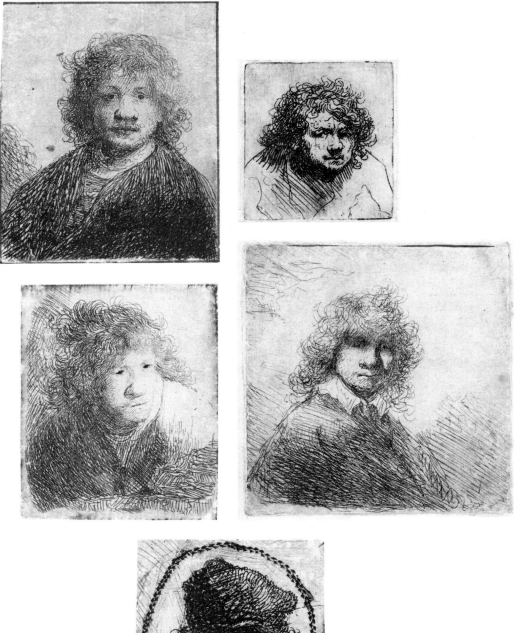

1: *c.* 1628 2: *c.* 1628

3: *c.* 1628 4: *c.* 1628

5 *c.* 1629

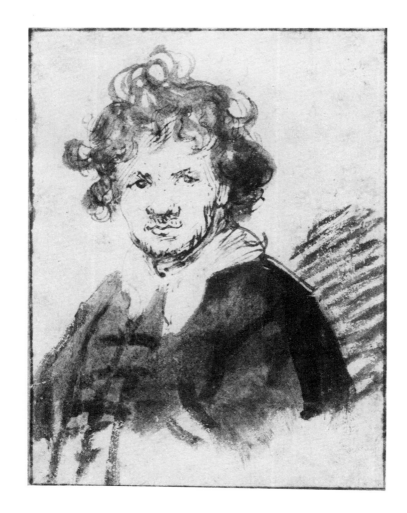

6: *c.*1628

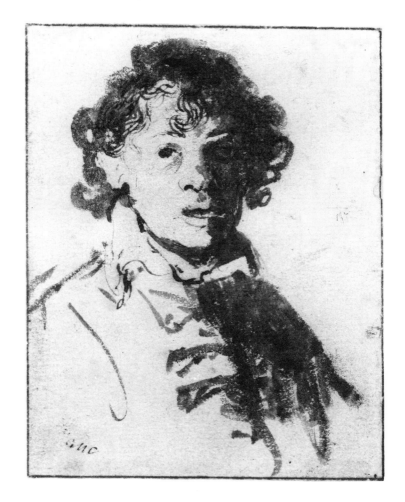

7: c. 1629

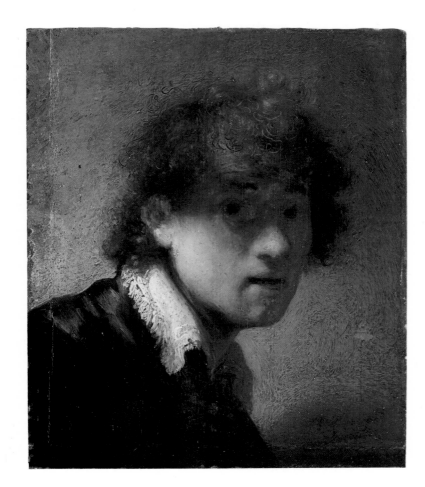

8: 1629

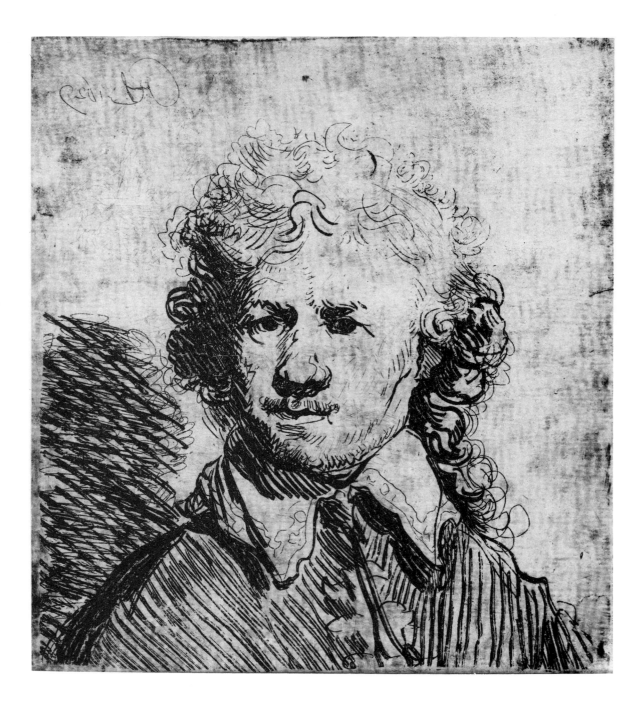

9: 1629

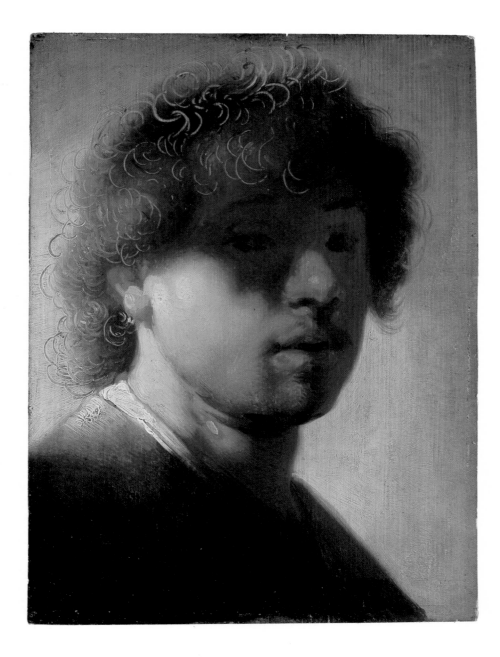

10: *c*.1629

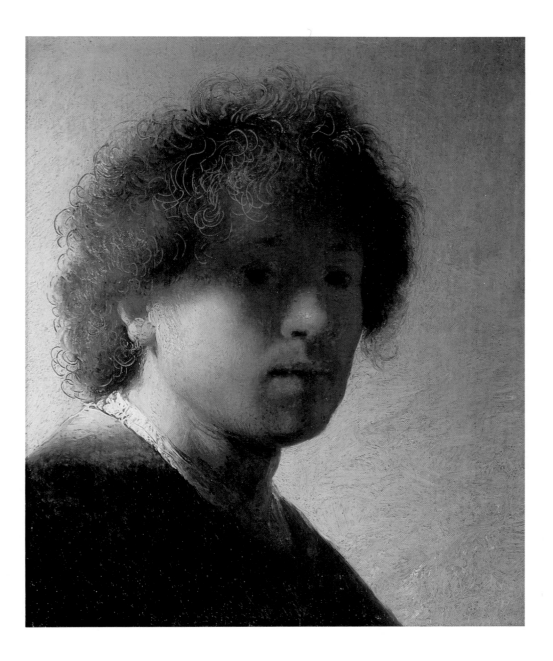

11: *c*.1629

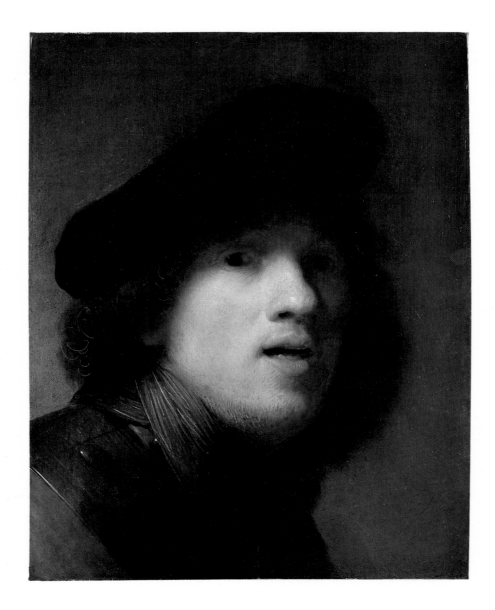

12: *c.*1629

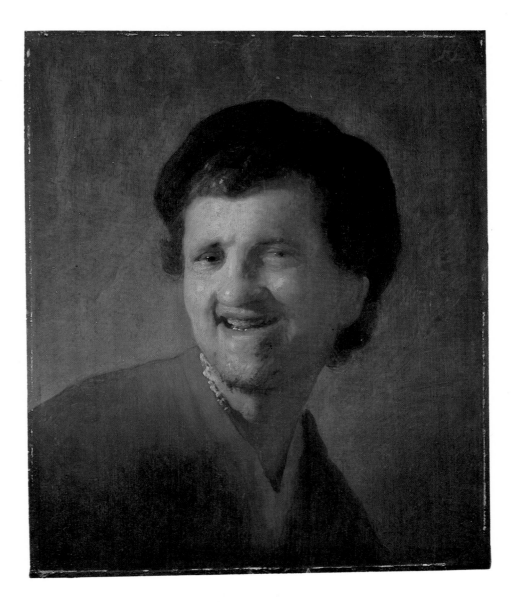

13: 1629-31

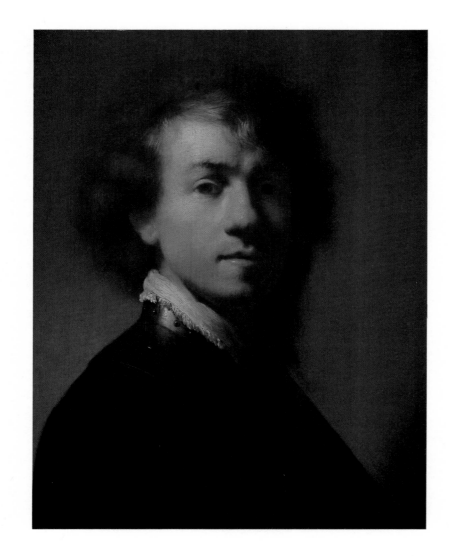

14: *c.* 1629

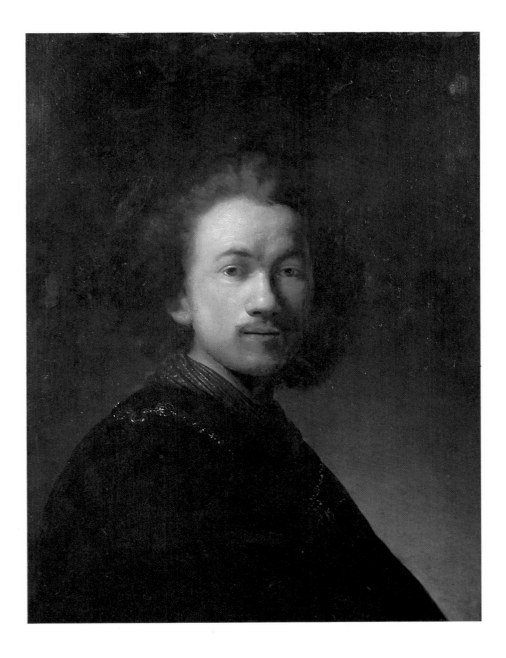

15: *c.*1629

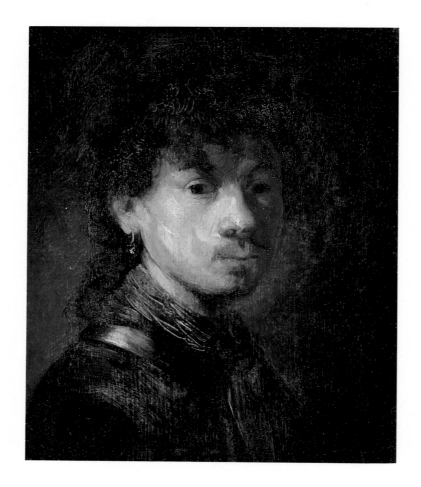

16: 1629

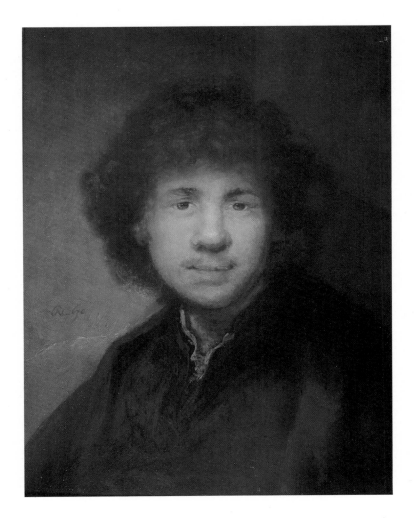

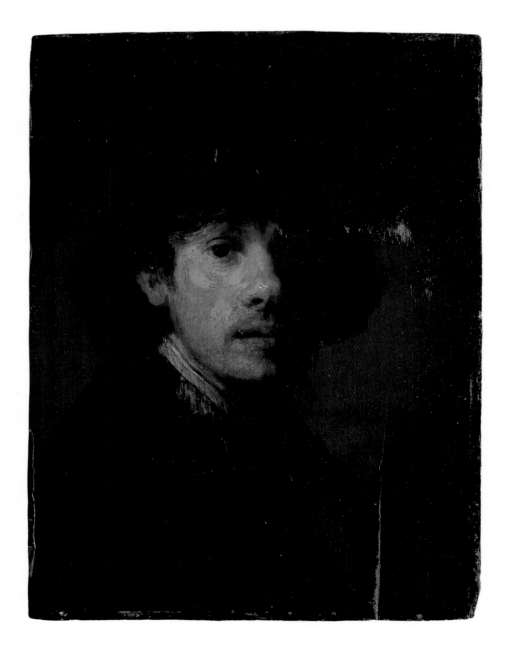

18: *c.* 1630

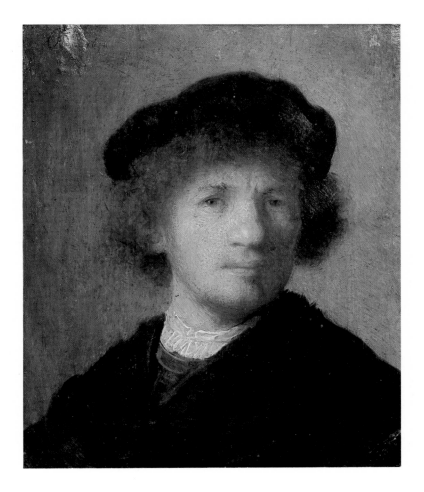

19: 1630[?]

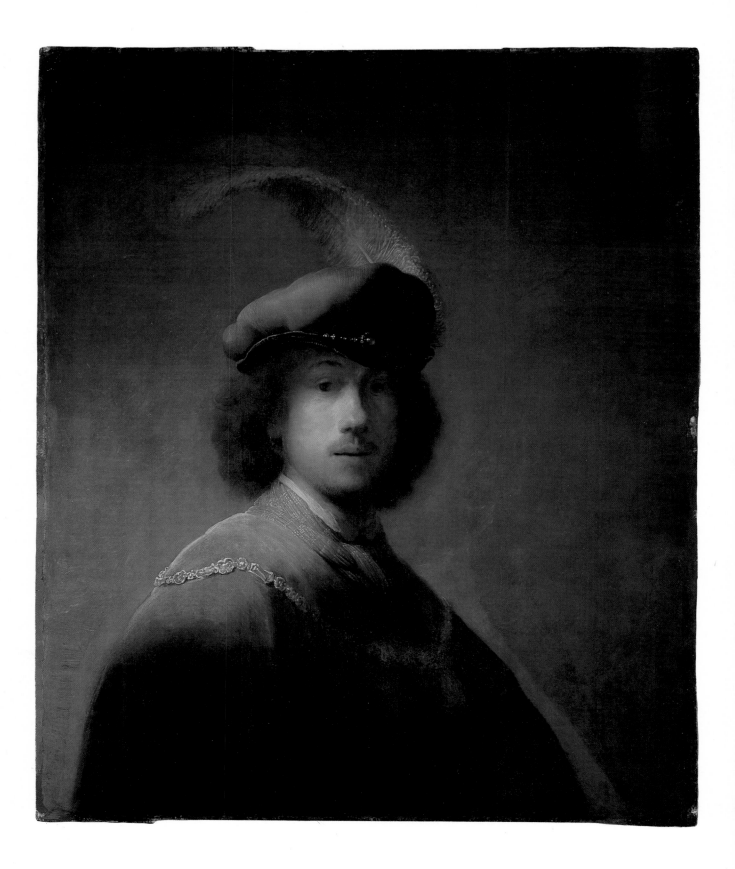

20: 1629

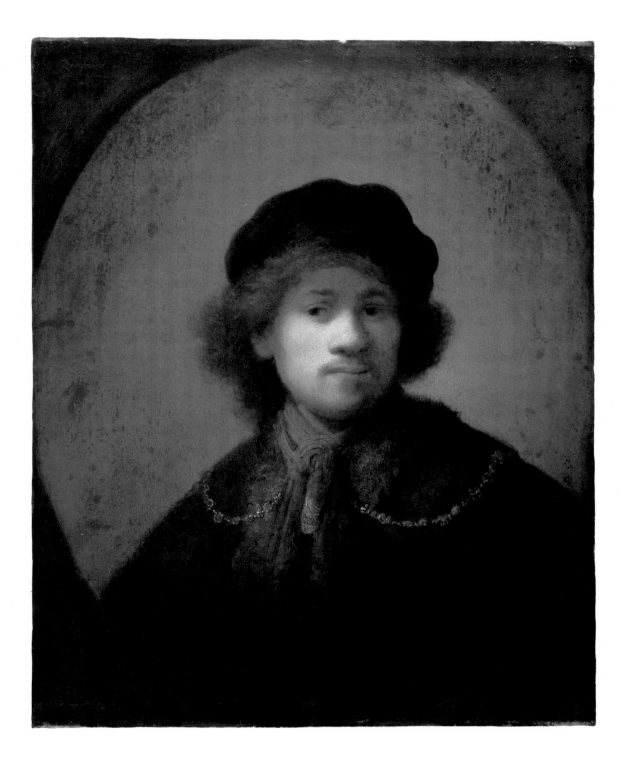

21: 1629[?]

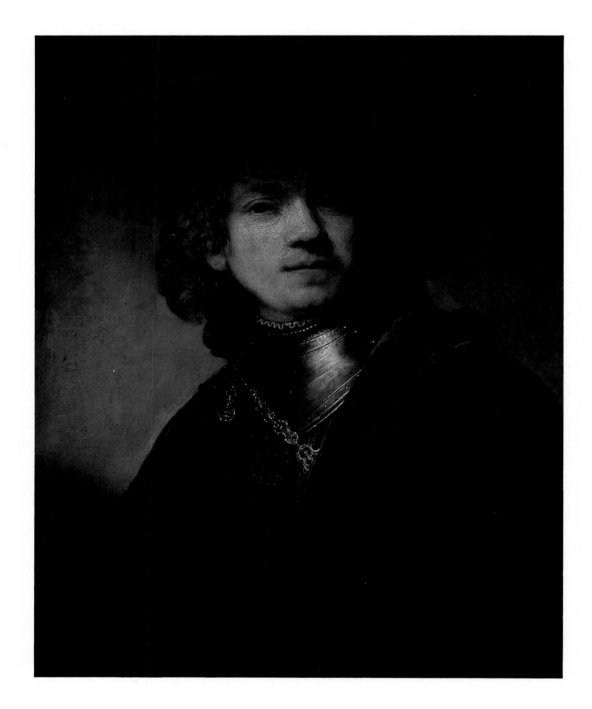

22: *c.* 1630

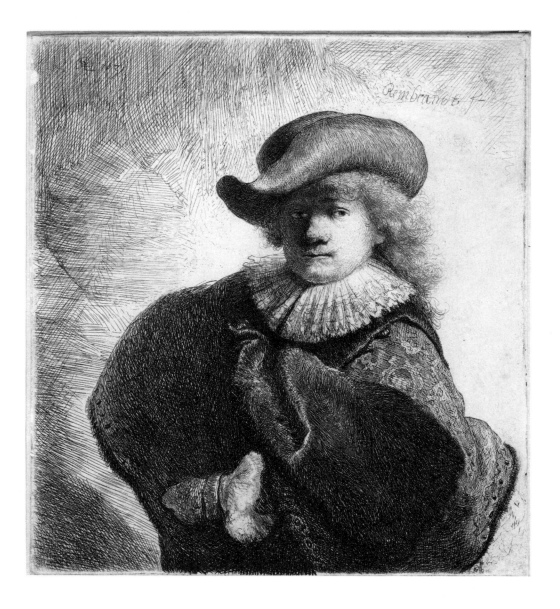

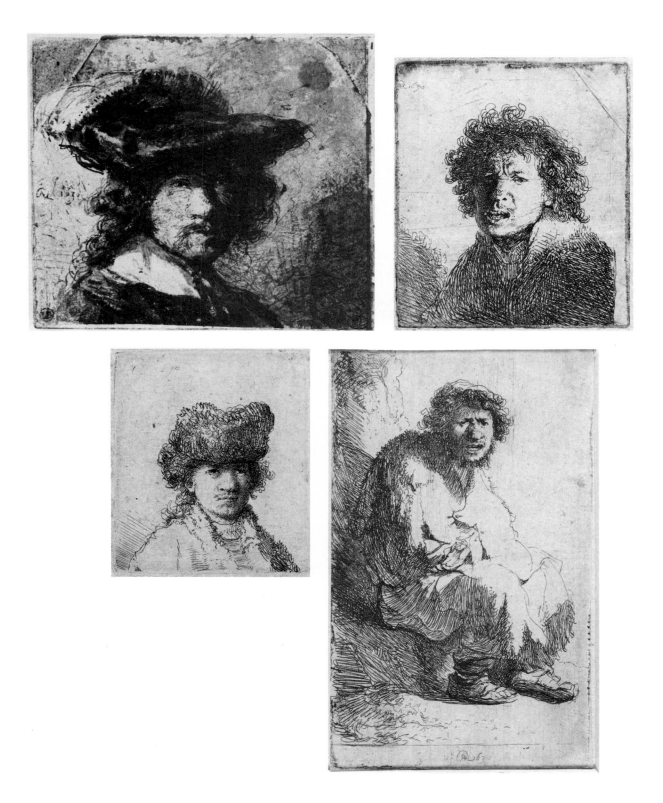

24: 1630 25: 1630
26: 1630 27: 1630

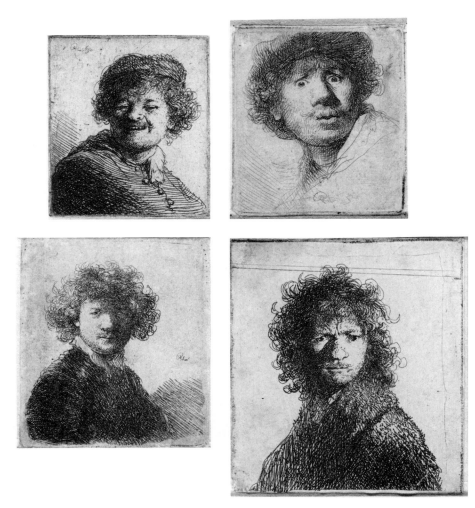

28: 1630 29: 1630

30: *c.* 1630 31: 1630

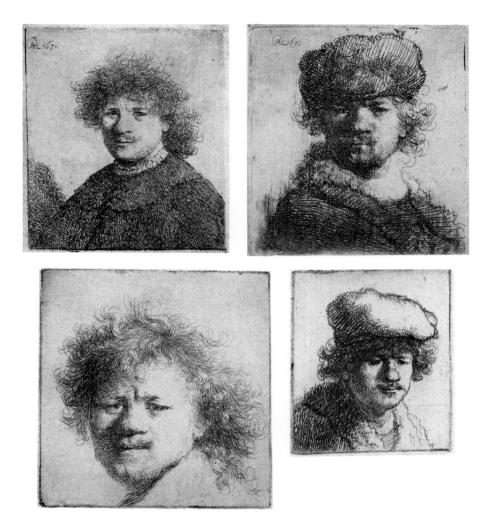

32: 1631 33: 1631
34: *c*. 1631 35: *c*. 1631

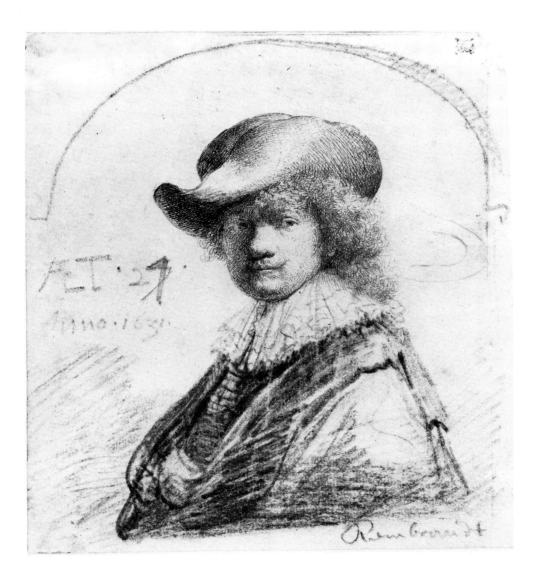

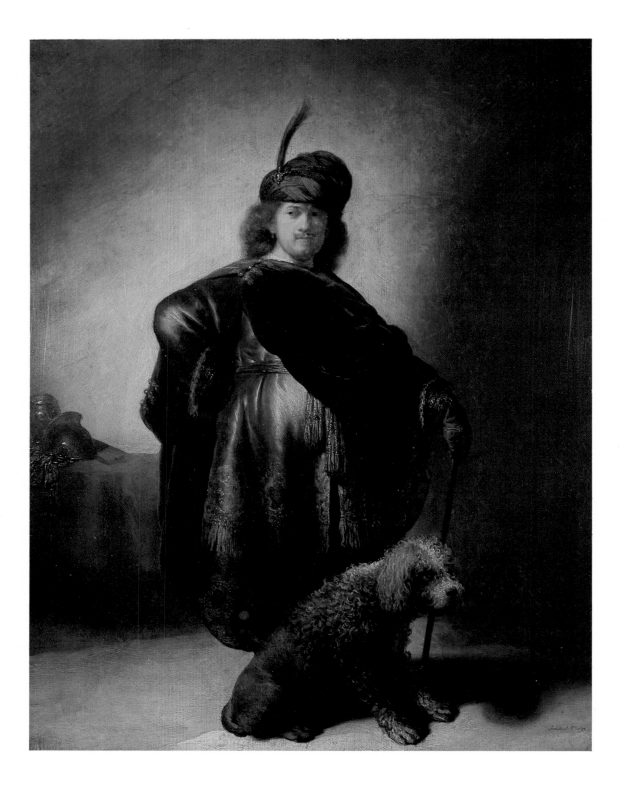

37: 1631

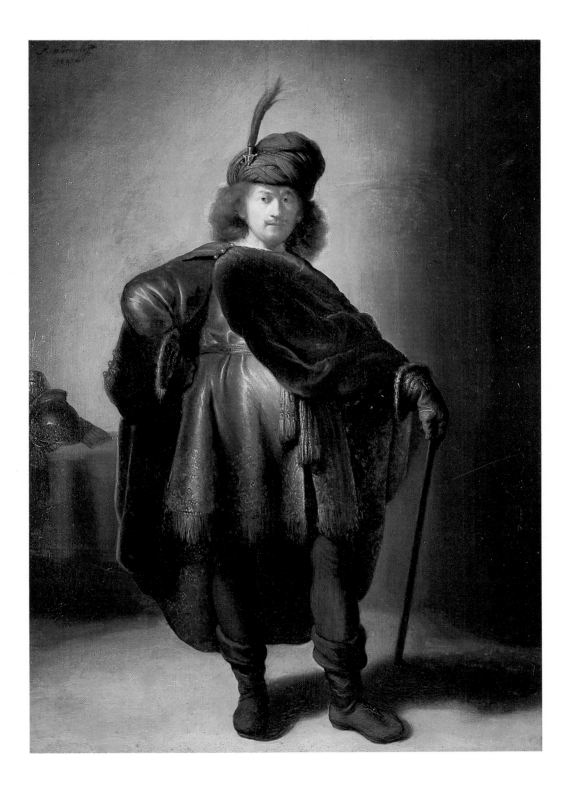

38: *c*.1631

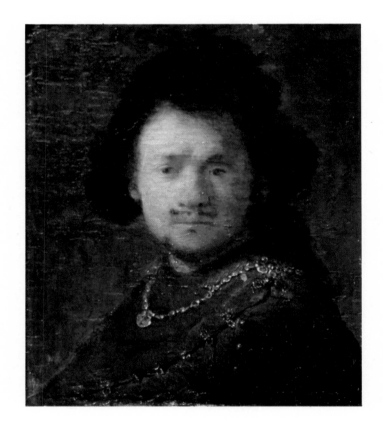

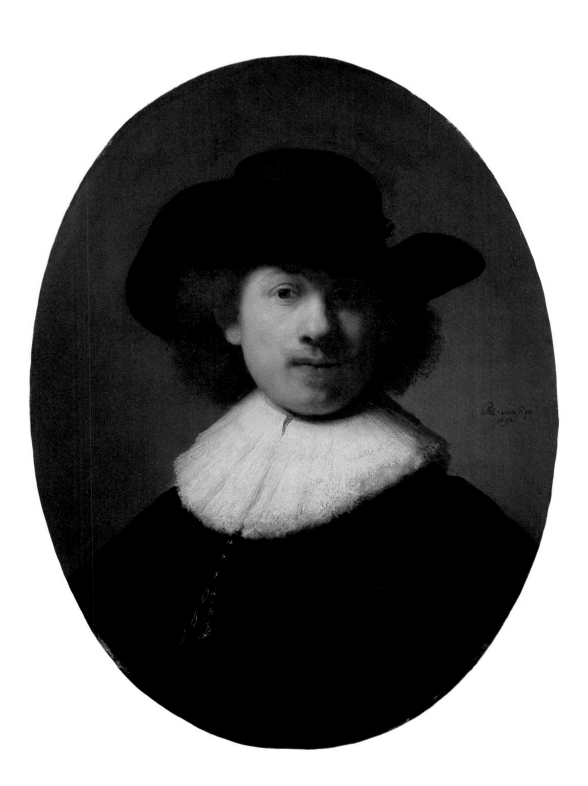

40: 1632

41: *c.* 1632

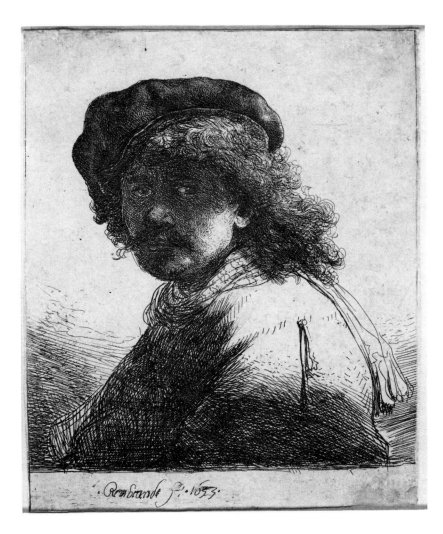

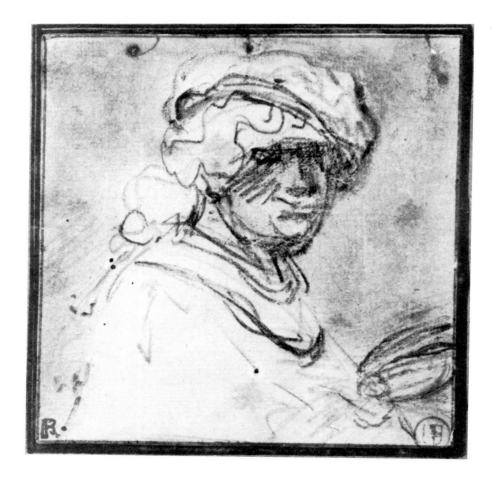

43: c. 1633

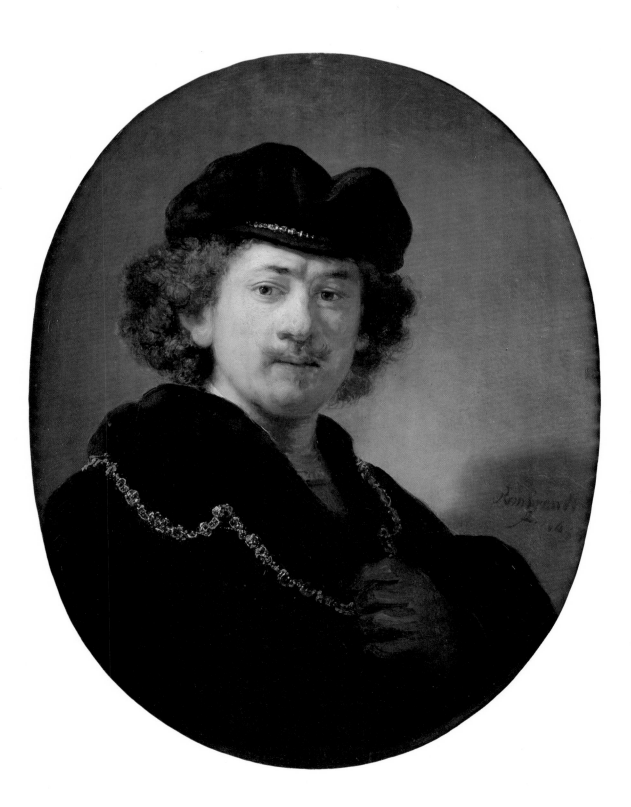

44: 1633

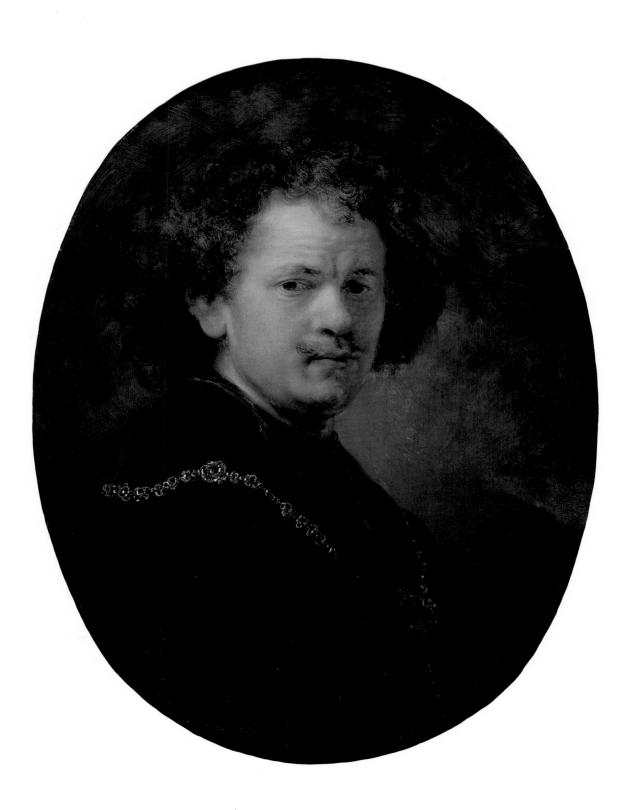

45: 1633

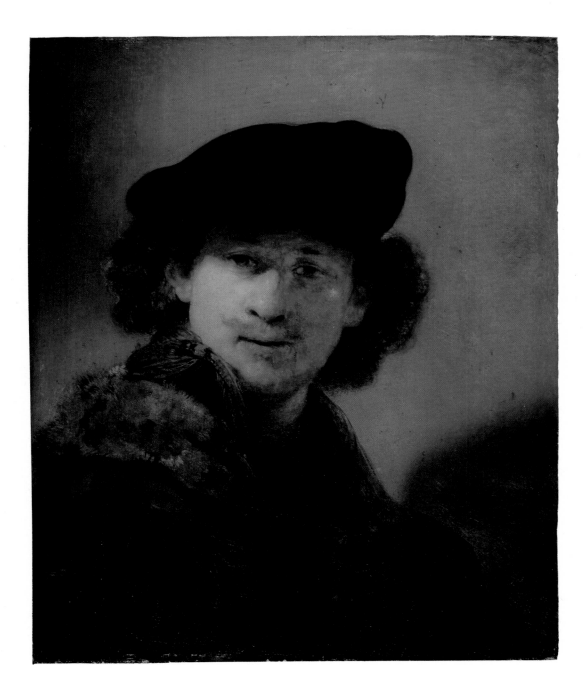

46: 1634

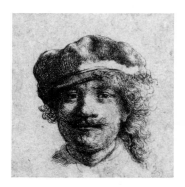

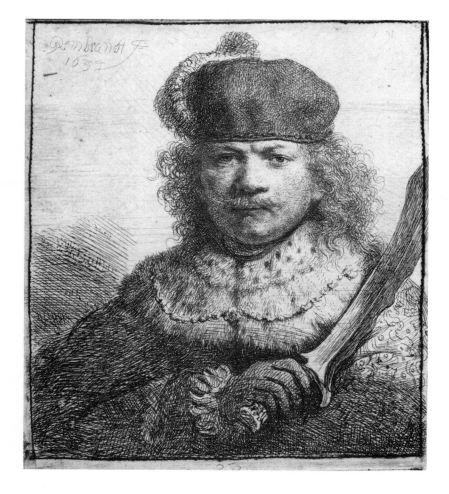

47: *c.*1634 48: 1634

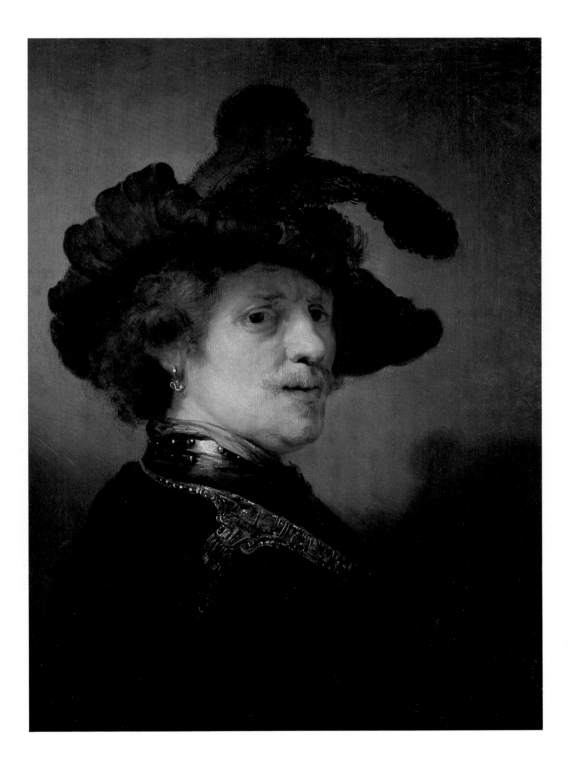

49: 1634–5[?]

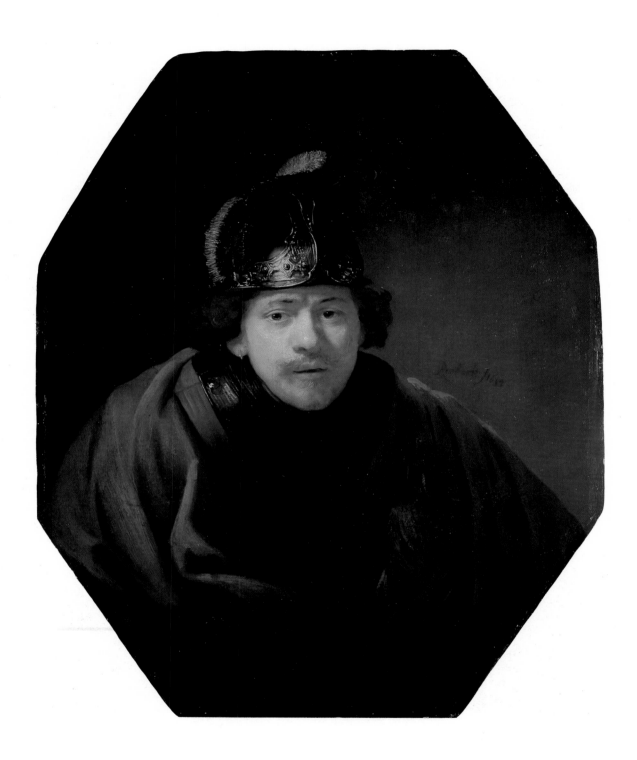

50: 1634

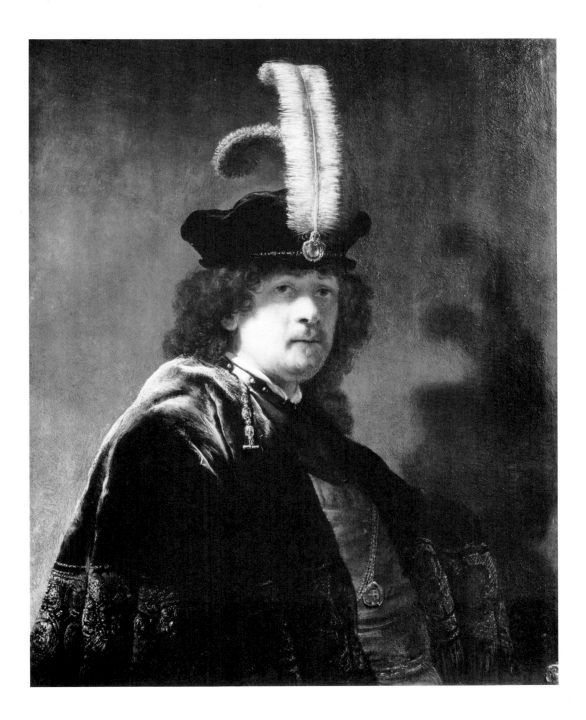

51 : 1635

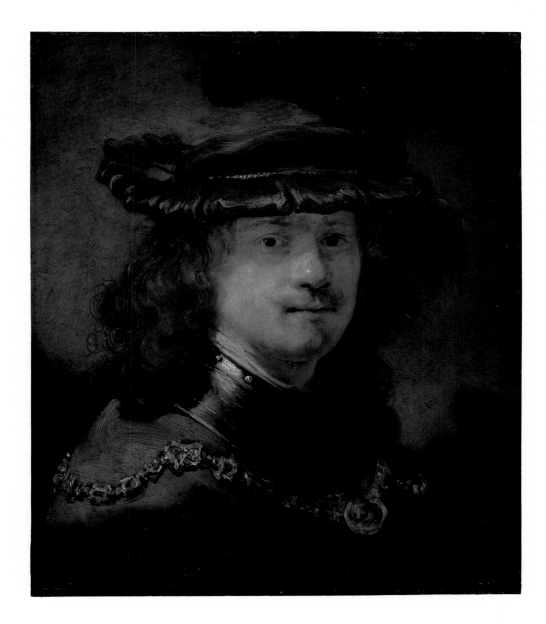

52: 1633-4

53: *c.*1635

54: *c.* 1635

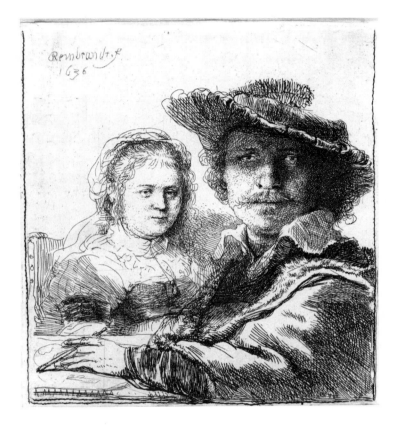

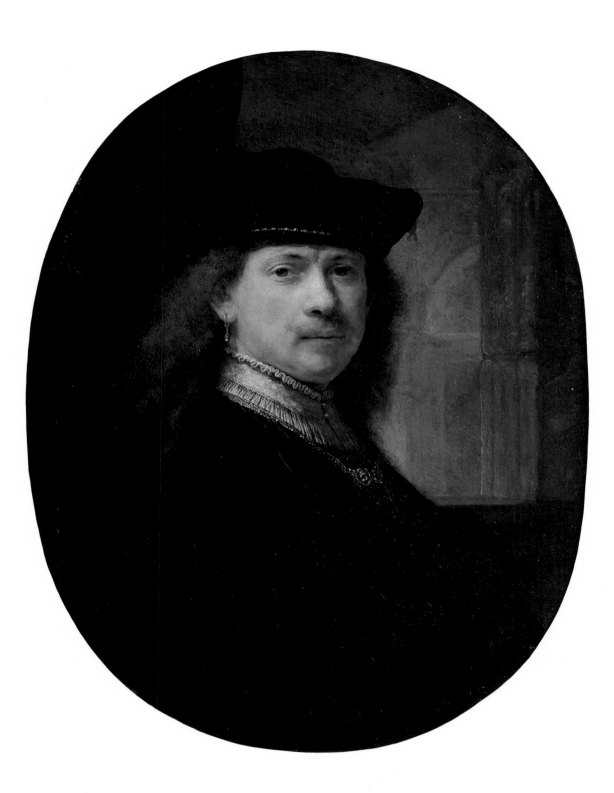

56: 1637

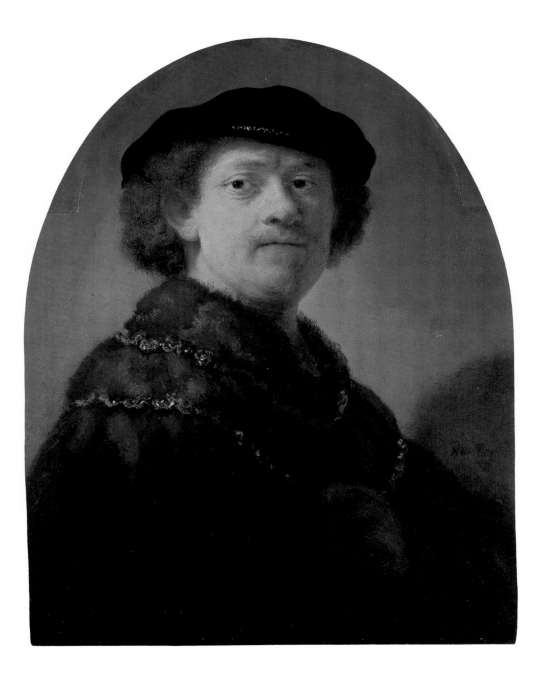

57: 1635-7

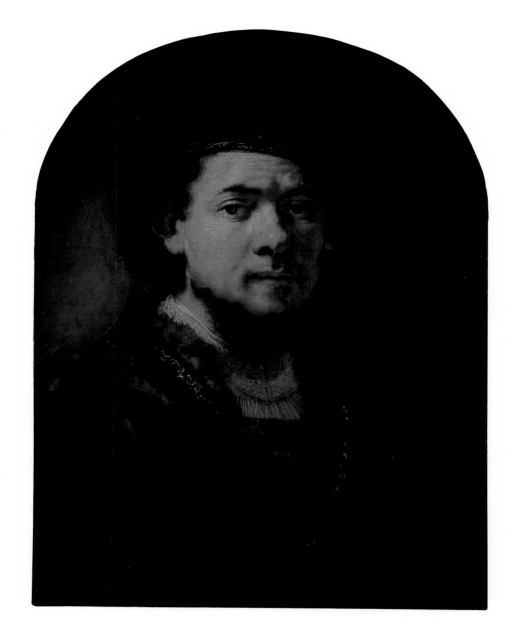

58: 1635-7

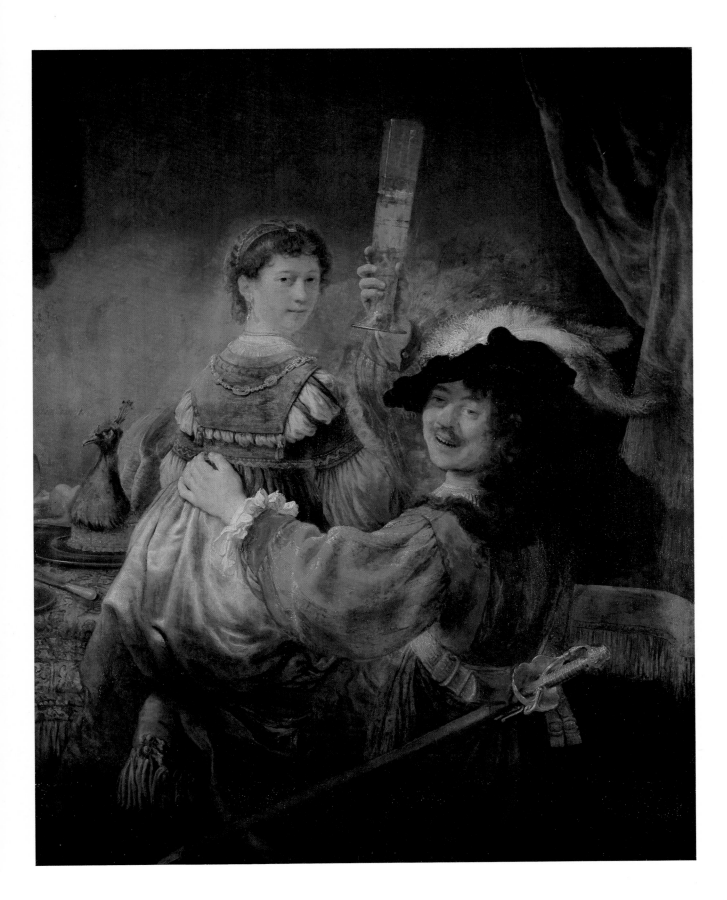

59: *c.* 1634

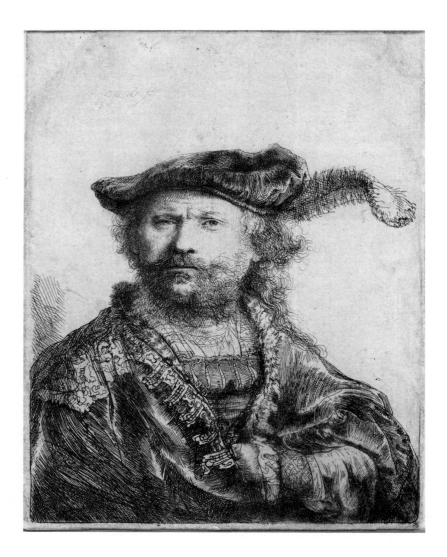

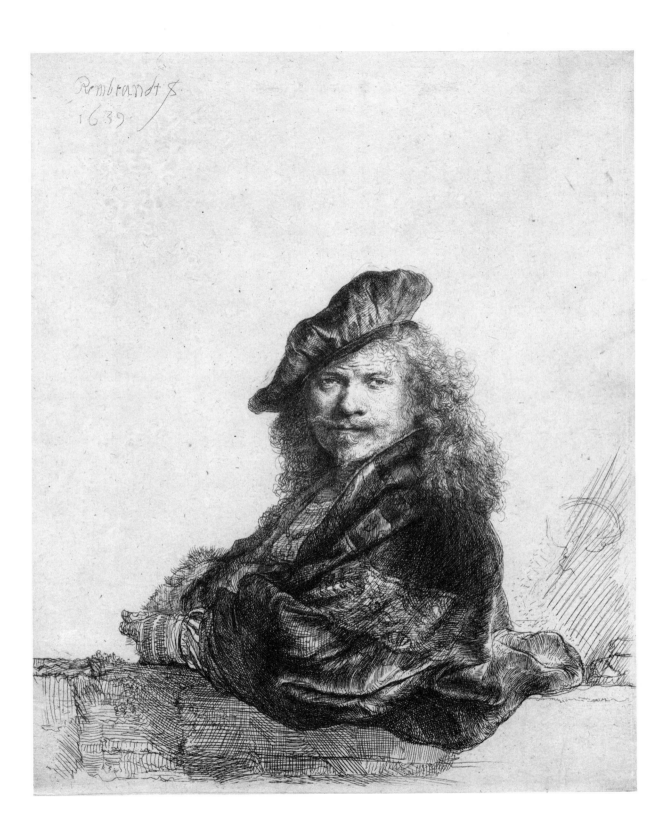

61: 1639

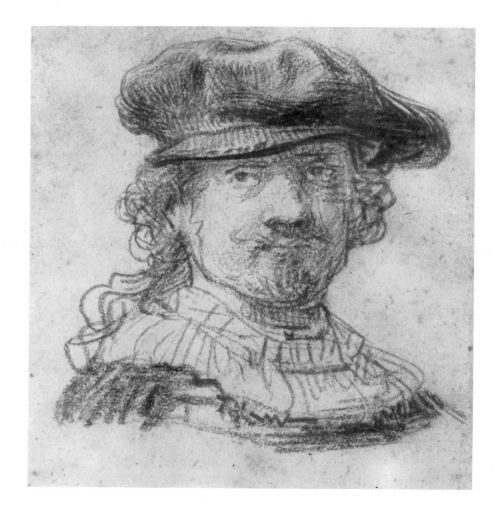

62: *c.* 1639

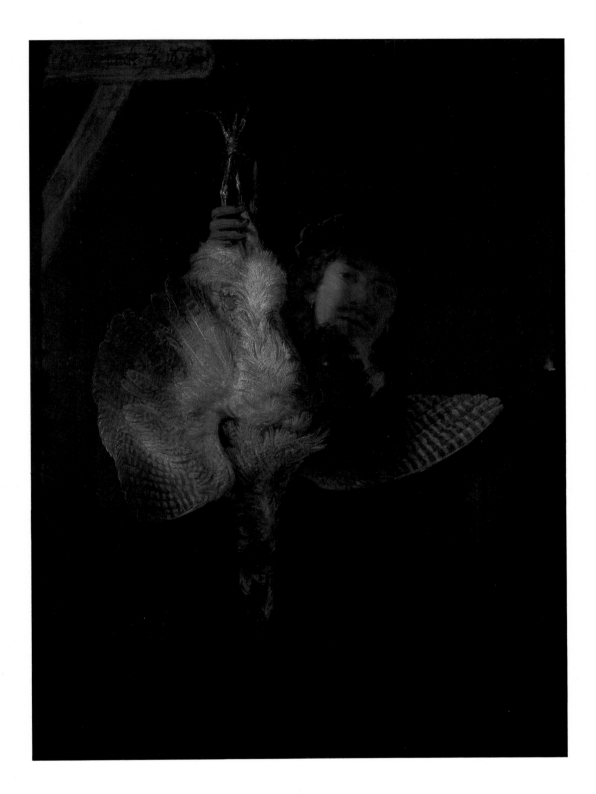

63: 1639

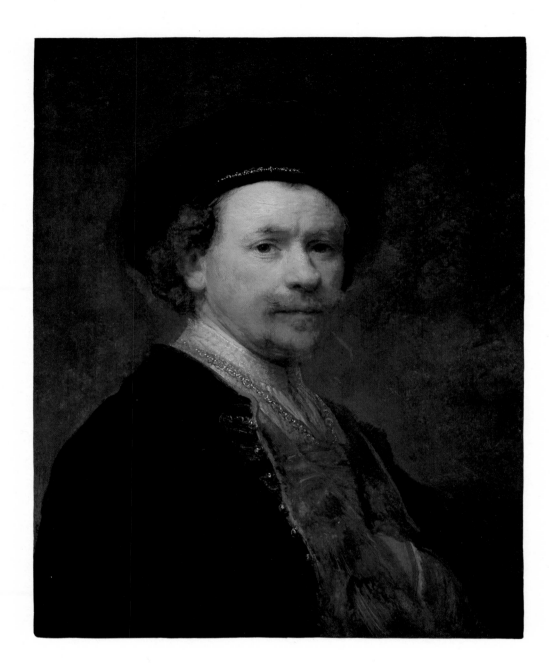

64: 1639[?]

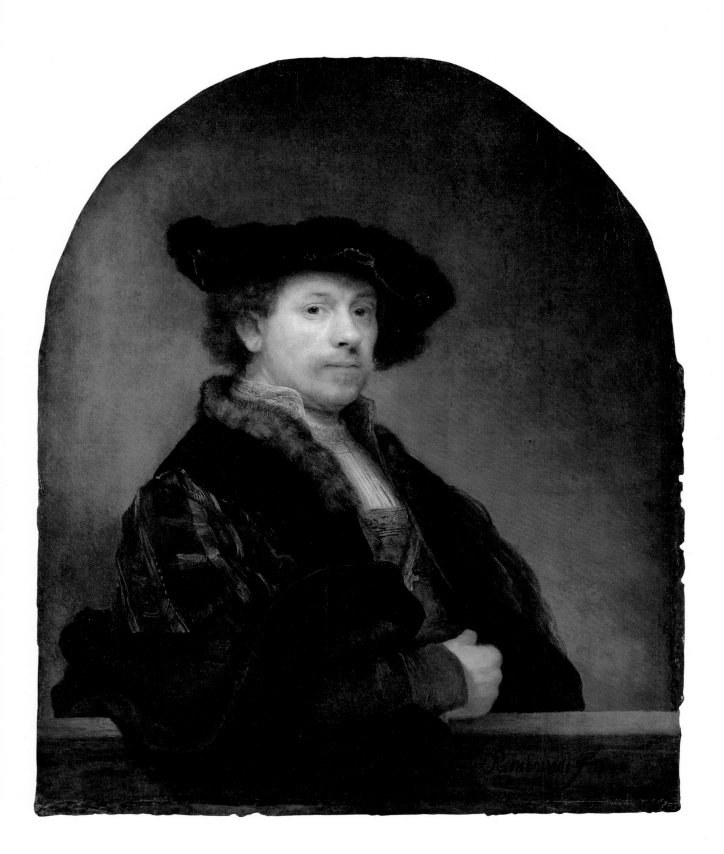

65: 1640

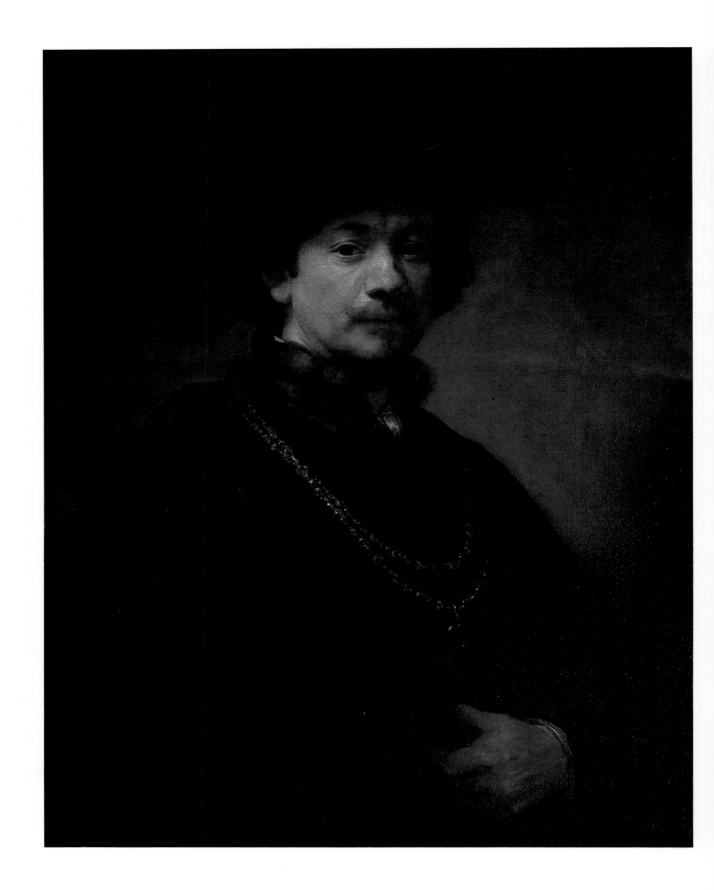

66: *c.* 1639

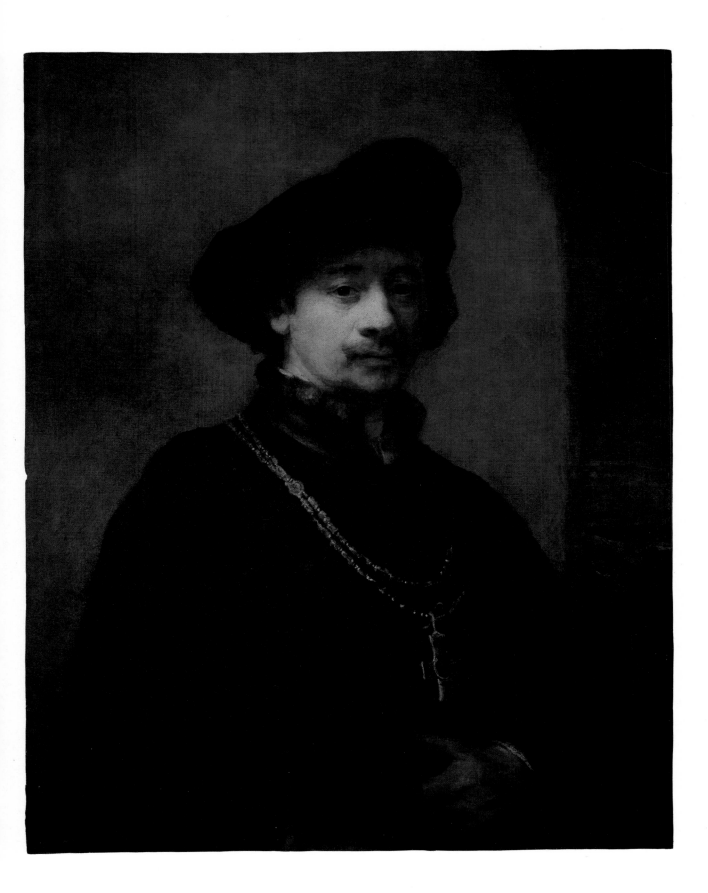

67: *c.* 1639

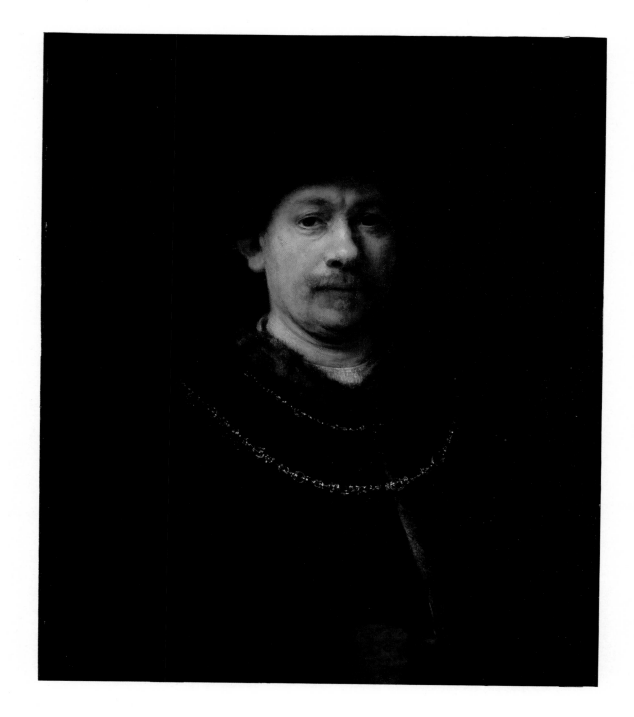

68: *c.* 1639

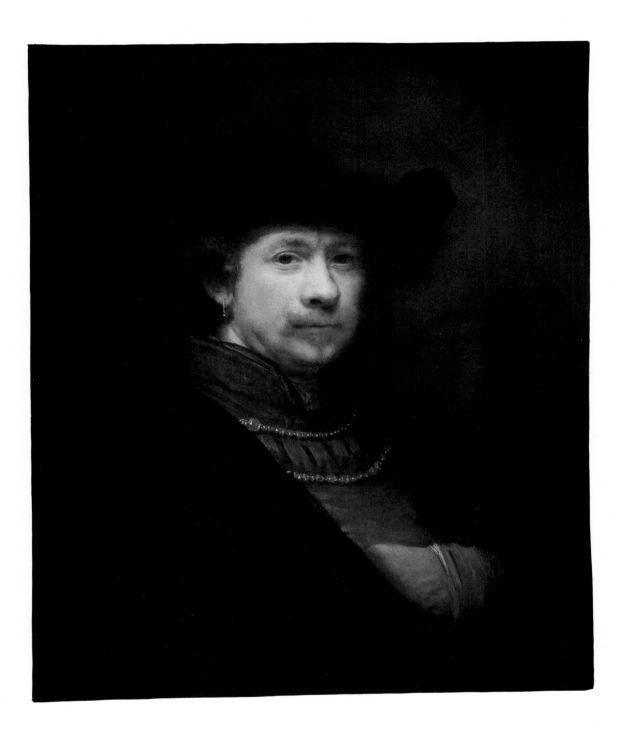

69: 164[?]

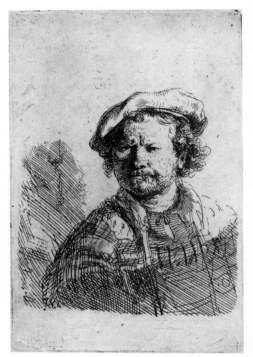

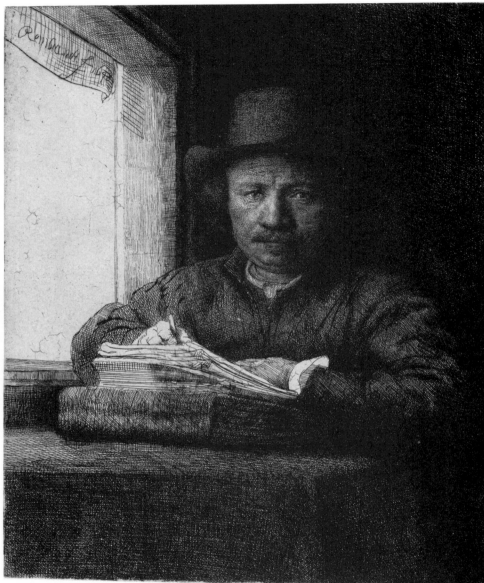

70: 1642 71: 1648

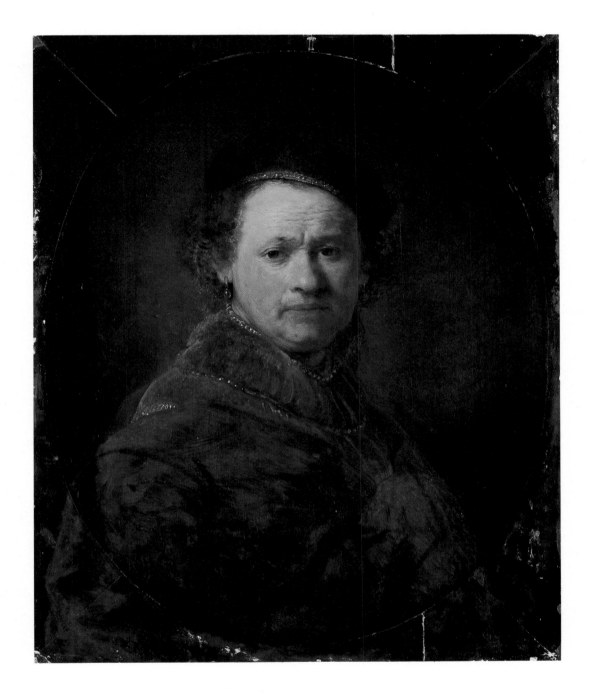

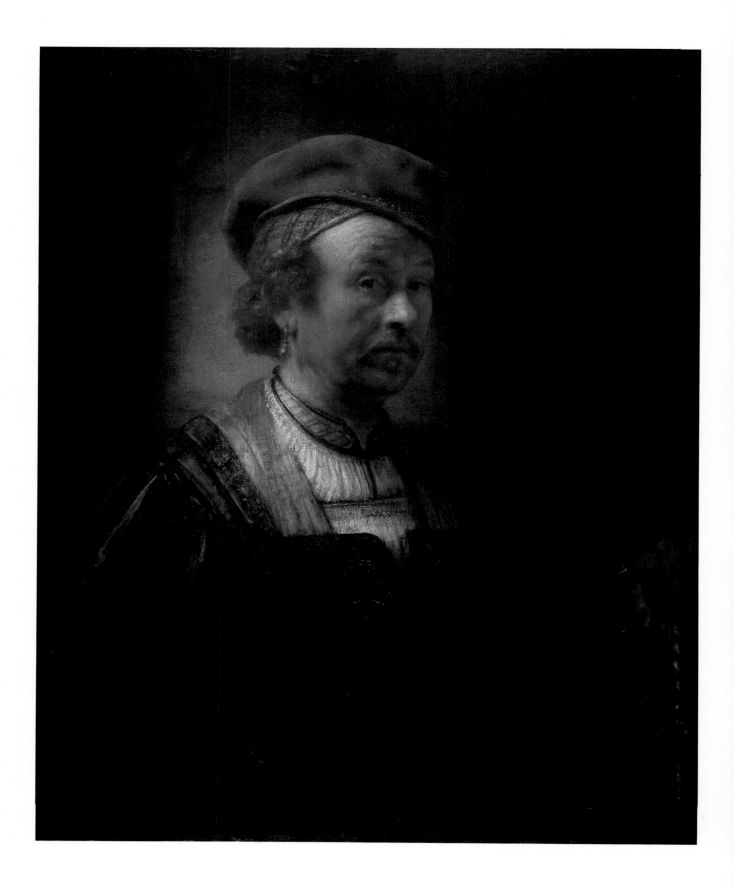

73: 1650

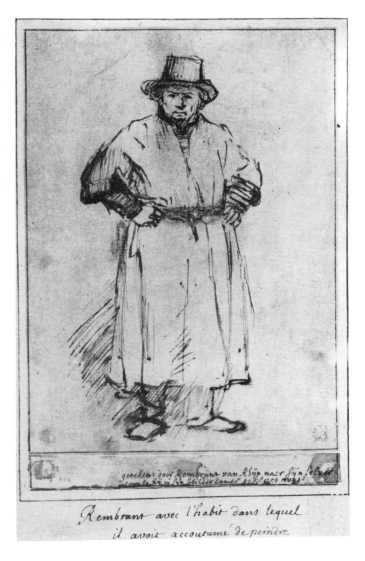

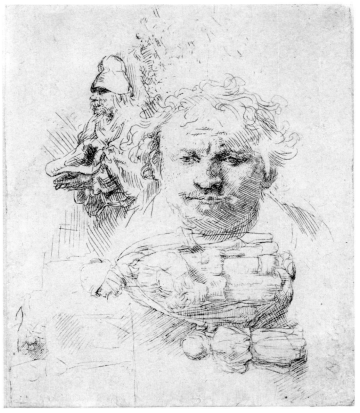

geteken door Rembrant van Rijn naer sijn selver
soo als hij in sijn Schilderkamer geklet ging

*Rembrant avec l'habit dans lequel
il avoit accoutumé de peindre*

75: c.1655 74: 1651

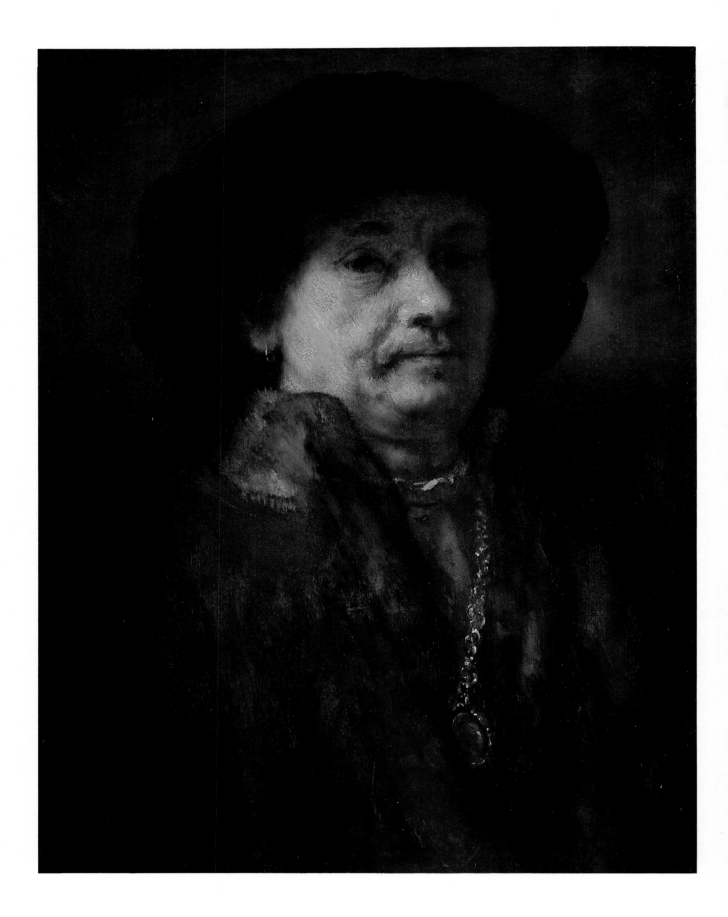

76: 1652

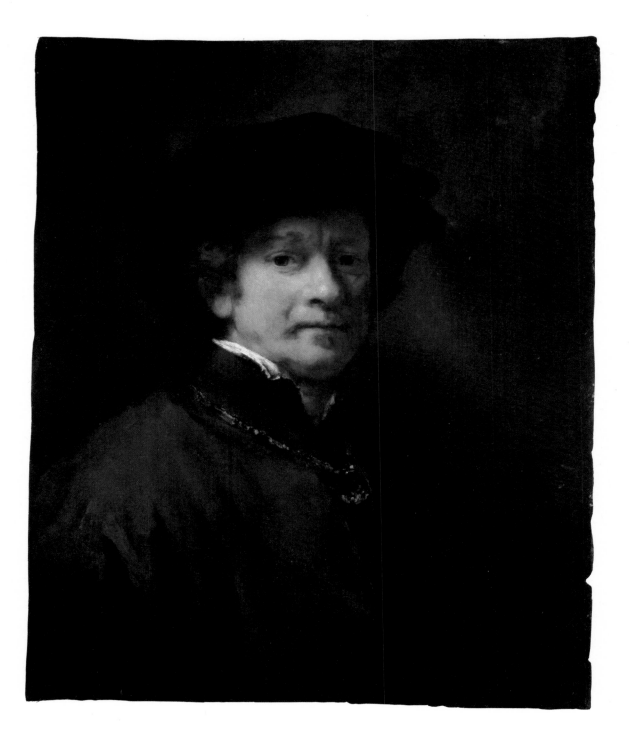

77: 1654/5

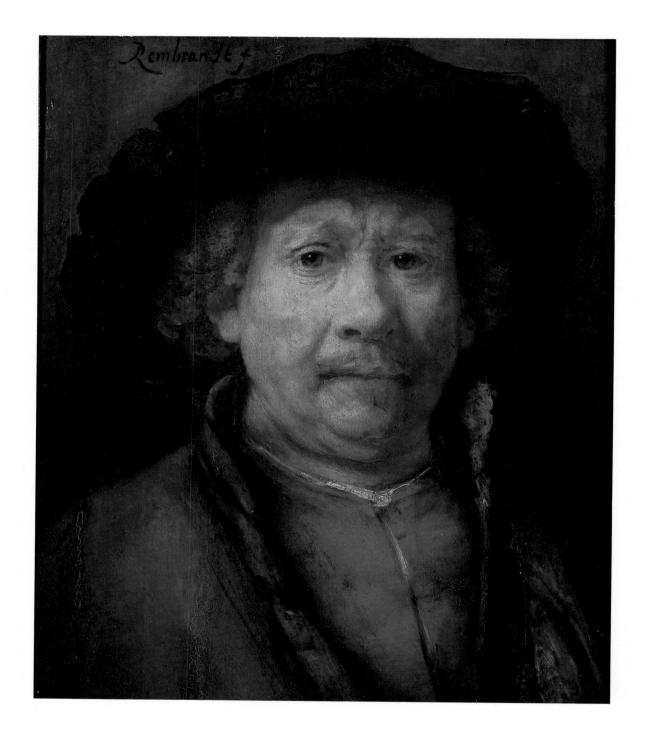

78: 1655

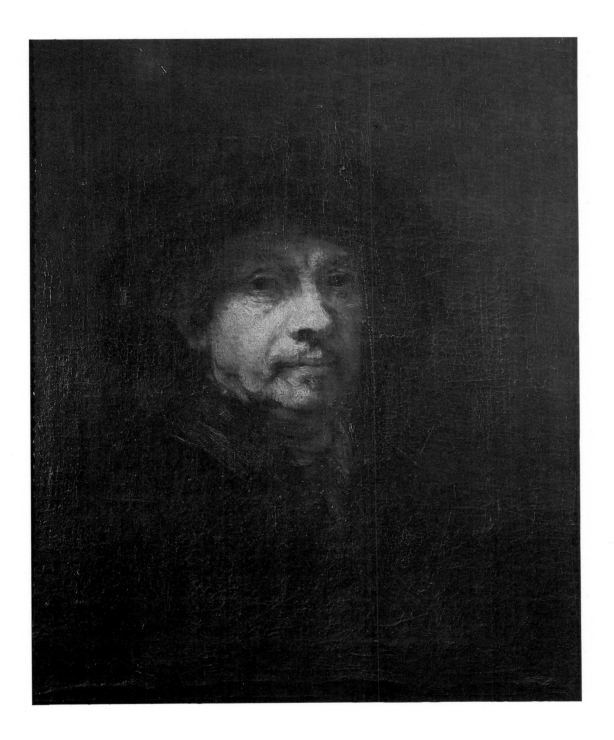

79: *c.* 1655

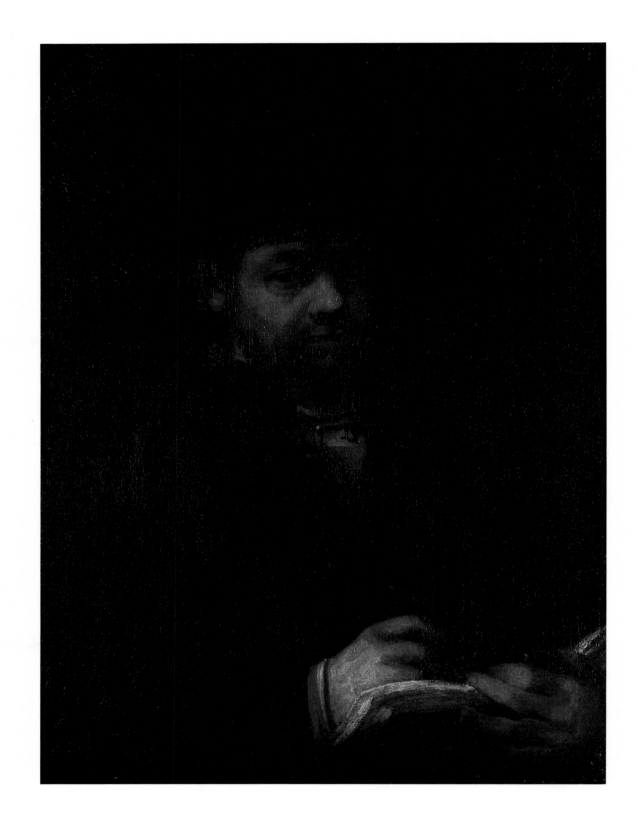

80: 1657

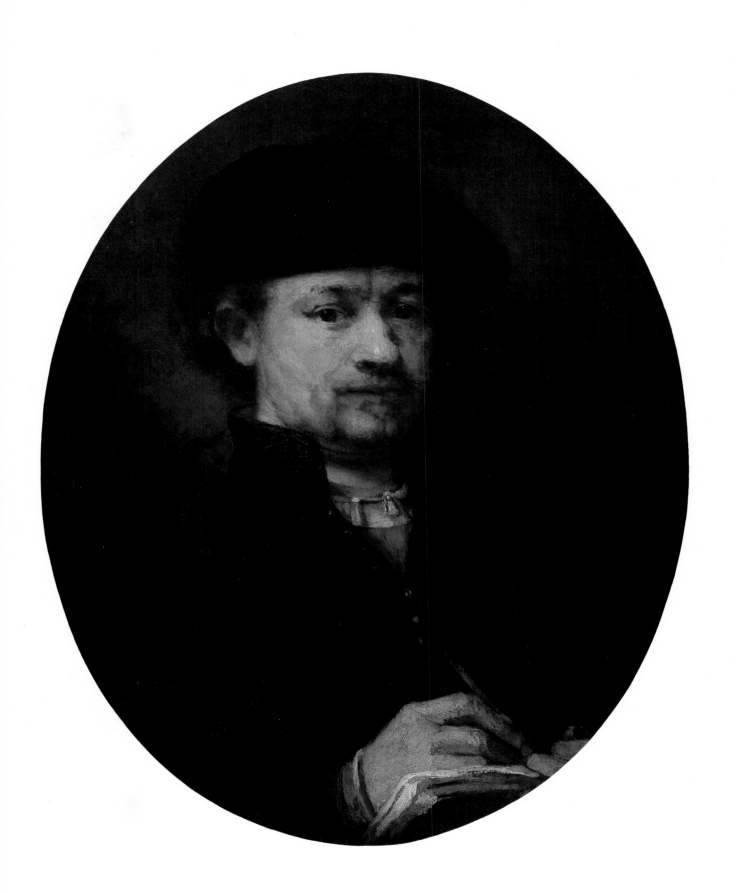

81 : 1653?

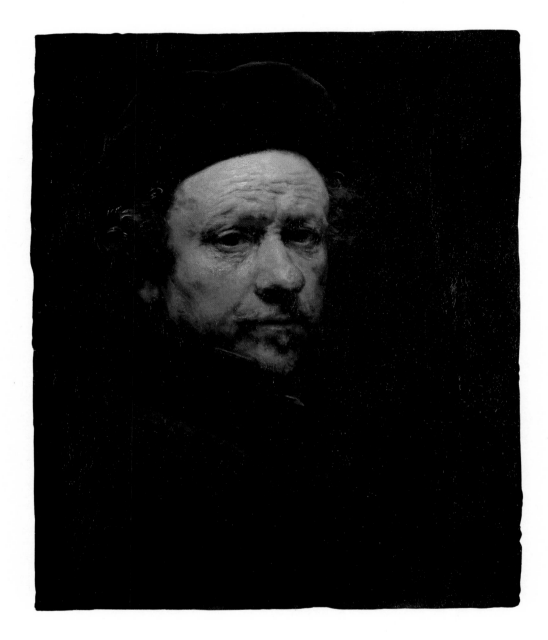

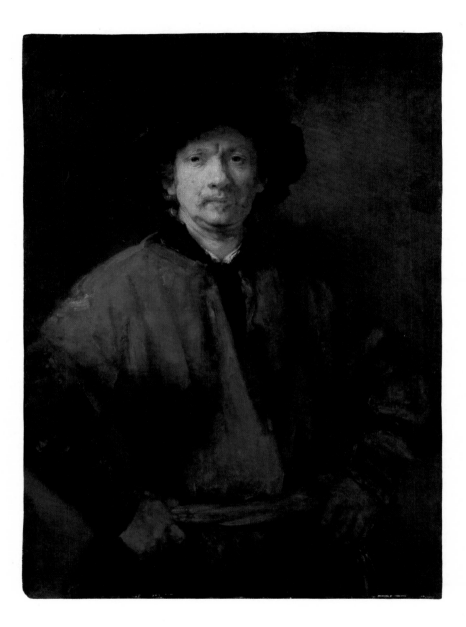

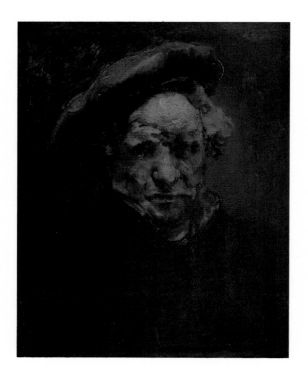

84: 1662-3?

85: *c*. 1660 86: *c*. 1658

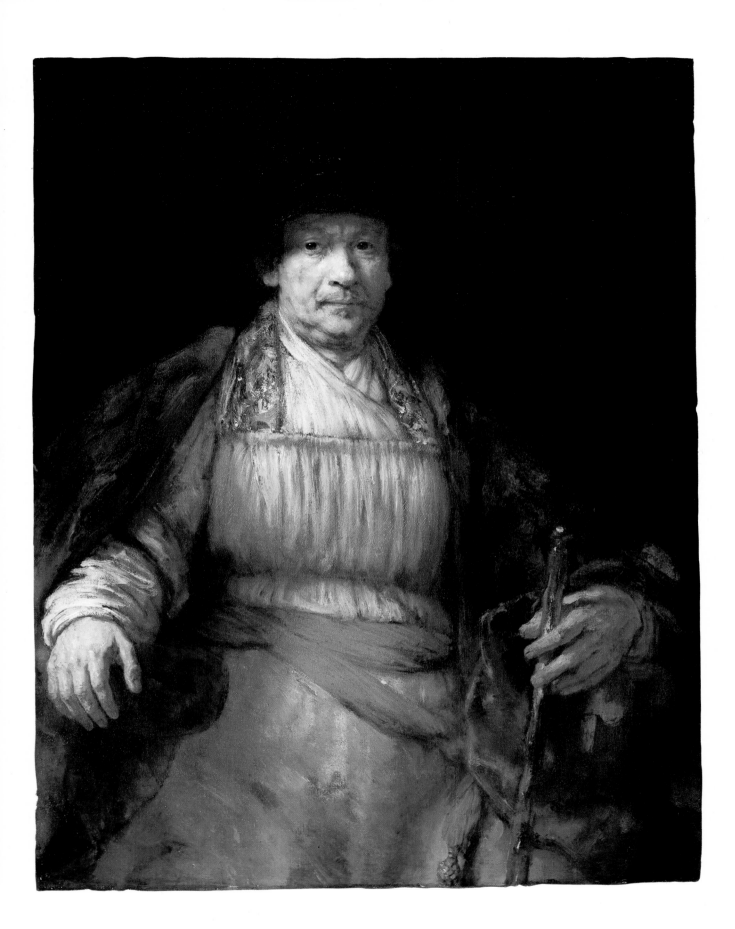

87: 1658

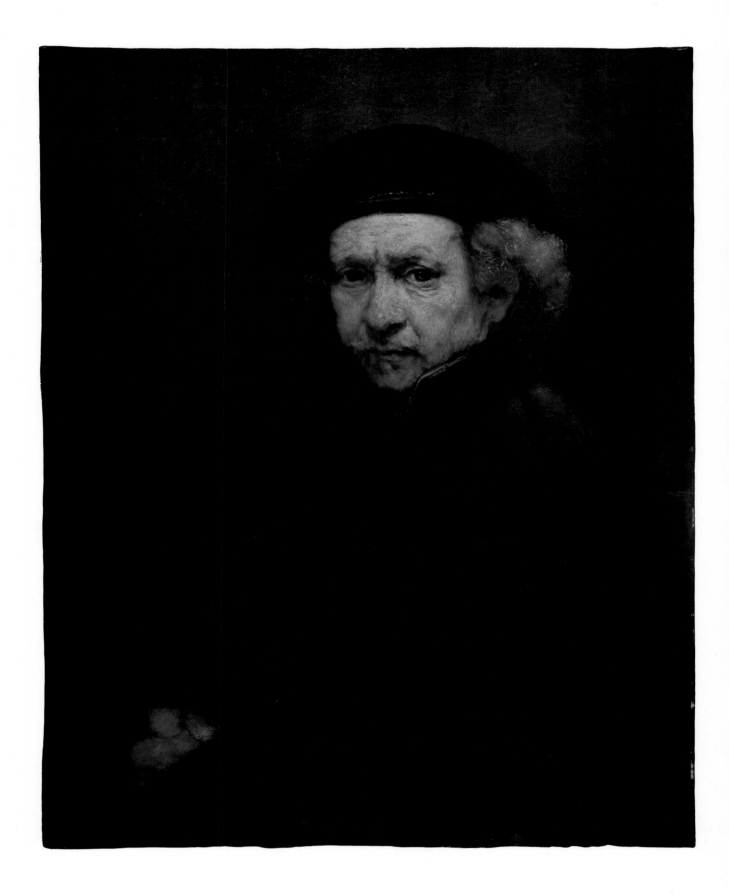

88: 1659

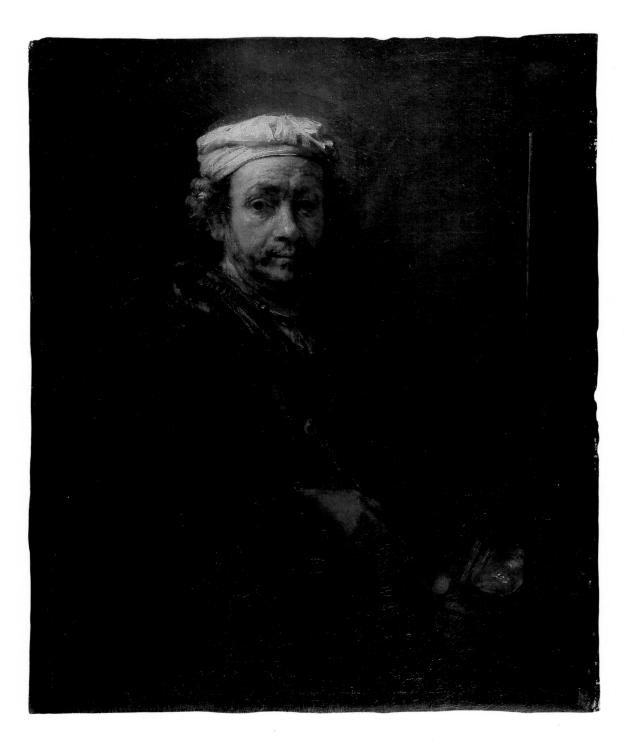

89: 1660

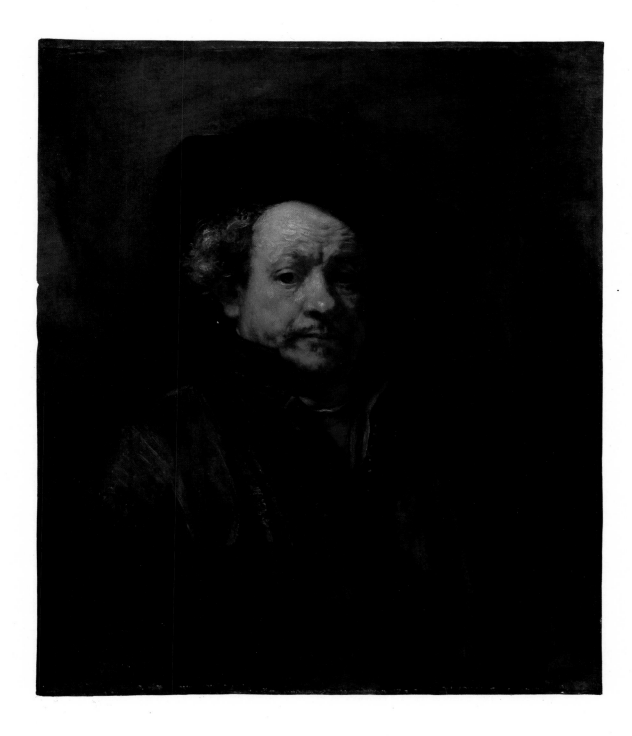

90: 1660

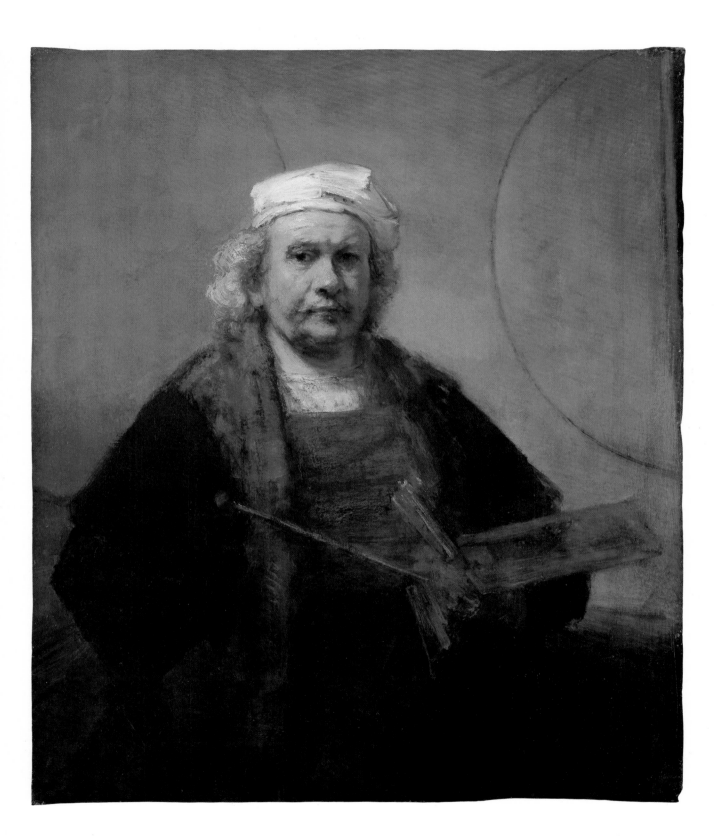

91: 1667-8?

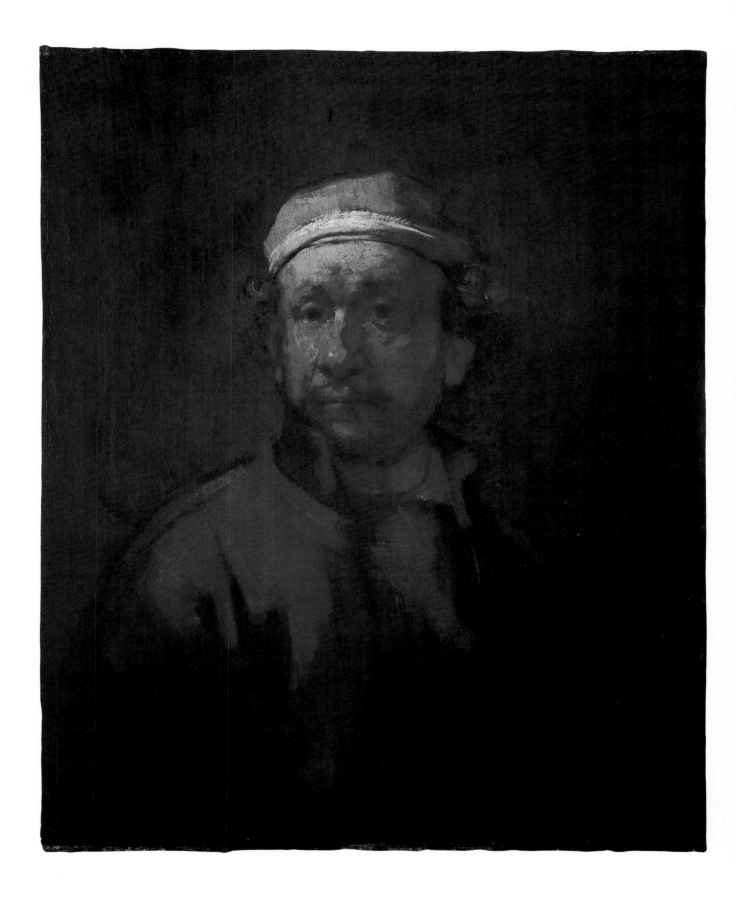

92: 1660

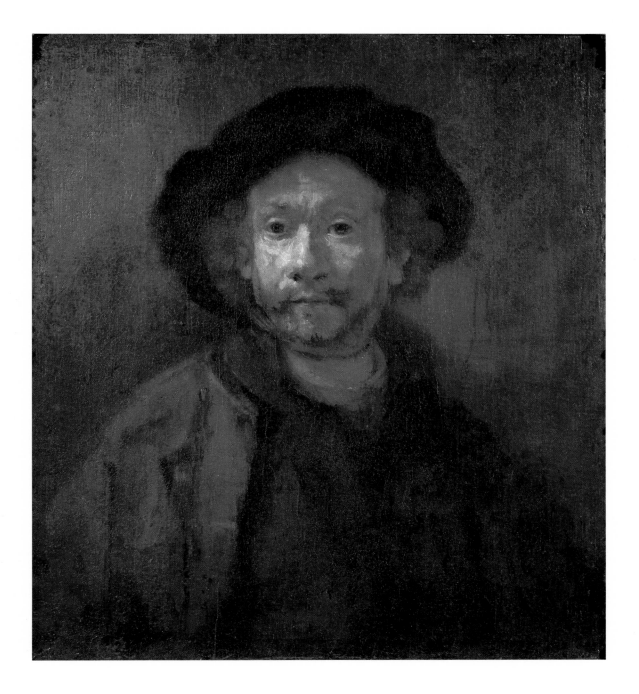

93: 1660

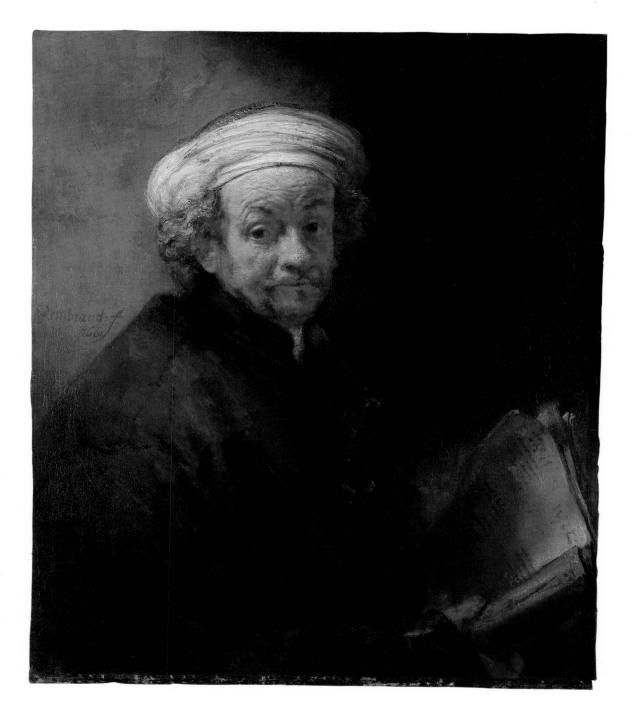

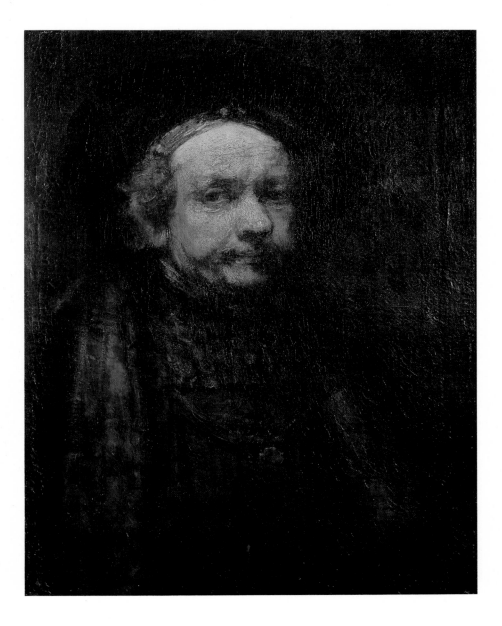

95: *c.* 1665

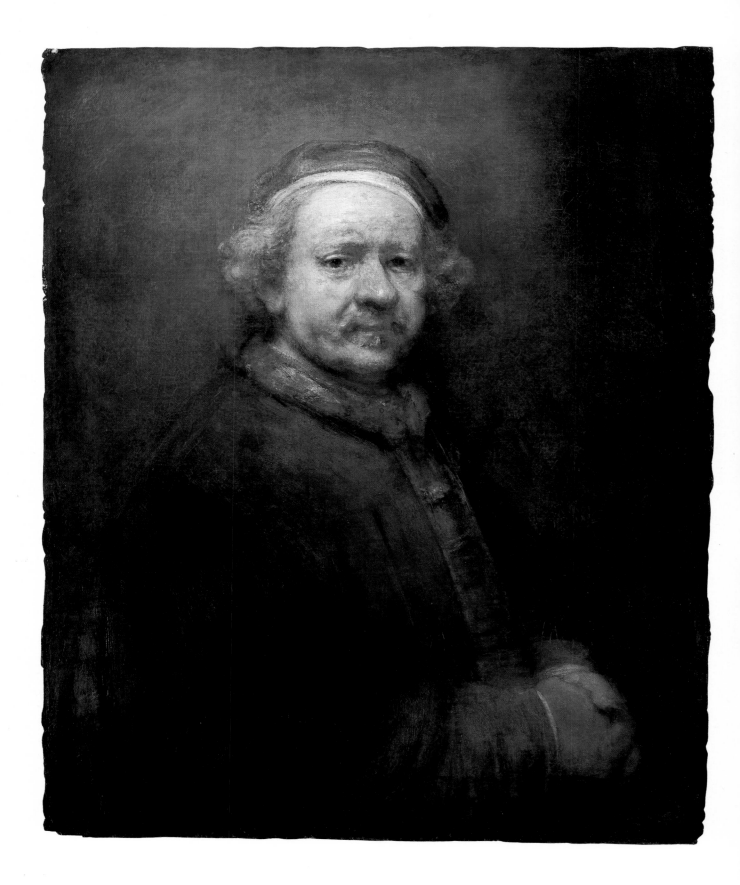

96: 1669

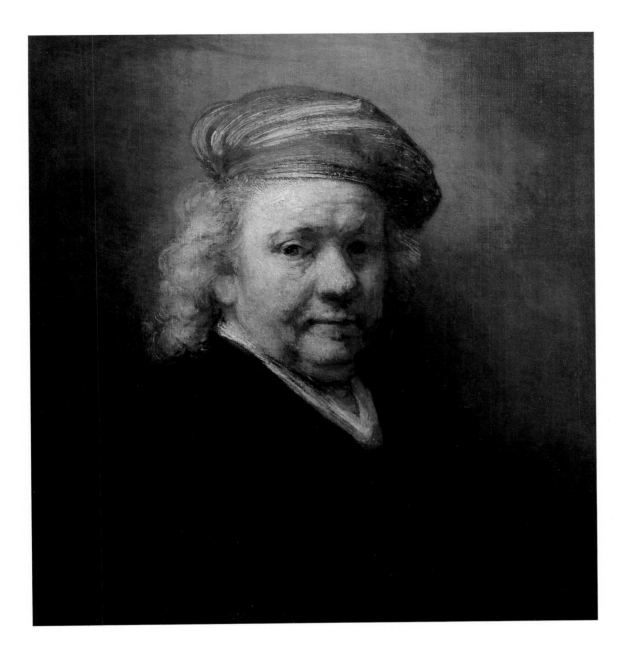

97: 1669

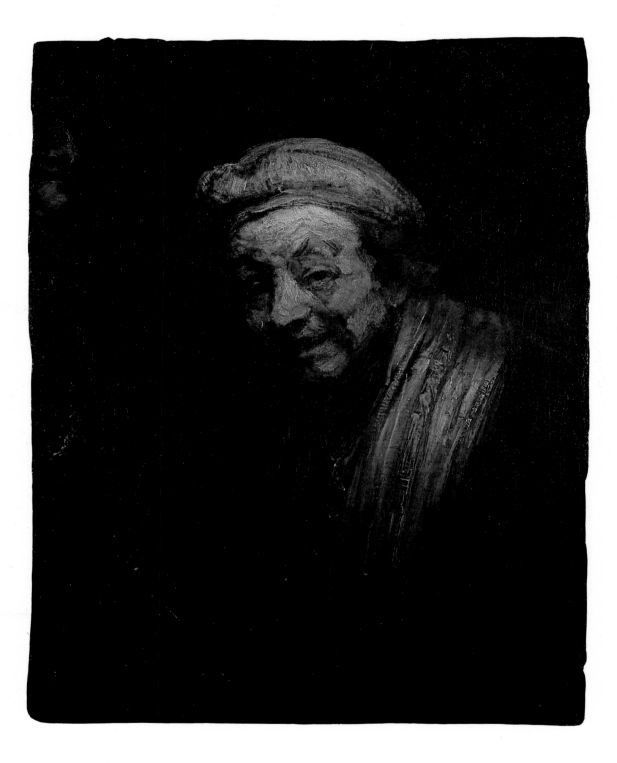

98: *c.*1669

A HISTORY OF REMBRANDT'S SELF-PORTRAIT PAINTINGS
AND THEIR REPUTATION.

This section sets out to record the main landmarks and the chequered history of taste in Rembrandt's art. The selection of material has concentrated on pictures considered to be important today or which happen to survive. Hofstede de Groot recorded an enormous number of other pictures which in most cases cannot now be traced.

REMBRANDT'S LIFETIME

Remarkably few pictures by Rembrandt are documented in his lifetime and very few self-portraits are mentioned at all. Not one of the documented pictures can be traced with certainty today.

1629: The Stadhouder Frederick Hendrick gave Lord Ancram three pictures by Rembrandt, including a self-portrait.

1633: Lord Ancram gave the *Self-portrait* he had received from the Stadhouder to King Charles I of England.

1639: Lord Ancram's *Self-portrait* appeared in van der Doort's inventory of the collection of Charles I, described as follows: 'Given to the Kinge by my Lo: Ancrom. Item above my Lo: Ankroms doore the picture done by Rembrandt being his owne picture and done by himself in a Black capp and furrd habbitt with a little goulden chaine upon both his shoulldrs. In an Ovall and a square black frame 2-4-1-11 (see Oliver Millar: 'Abraham van der Doort's Catalogue of the collections of Charles I'. *Walpole Society* Vol. XXXVII, 1958-1960).

1651: Charles I's picture was sold in the Commonwealth sale, 19 December 1651 to Major Edward Bass for £5. The subsequent history of this, the only well-documented Rembrandt self-portrait from his lifetime, is not known. The picture in the Walker Art Gallery, Liverpool (Plate 21) matches the description and dimensions. Hofstede de Groot preferred to identify Charles I's picture with the *Self-portrait* of 1633 in the Louvre (Plate 45) and although the description fits, the Paris picture has now been found to have had a different history.

1656: No self-portrait was recorded in the famous inventory of Rembrandt's effects drawn up at the time of his insolvency.

1657: (HdG. 585a) A *Self-portrait in Antique Costume* was in the sale Johannes de Renialme in Amsterdam on 27 June 1657, as lot 292. (HdG. 604) In the same sale, as lot 302, was a *Portrait of Rembrandt with Gerard Dou*.

THE FIRST FIFTY YEARS AFTER THE ARTIST'S DEATH

Rembrandt's paintings entered a period of total obscurity and it appears that he was not very highly esteemed. Many living painters like Adriaen van der Werff were at that time at the height of their fame and connoisseurs preferred a much more polished technique than that found in most of Rembrandt's pictures.

1677: A *Portrait of Rembrandt with his Wife* was recorded in the collection of widow Louys Crayers, Amsterdam.

1686: Baldinucci recorded the existence of two Rembrandt *Self-portraits* in the Uffizi Gallery in Florence (Plates 79 and 95).

1689: (HdG. 585b) A *Head* was recorded in the inventory of the effects of William Spieringh, Delft.

1690/91: The *Self-portrait* of 1660 in the Louvre (Plate 89) was recorded in the inventory drawn up by the painter Charles Le Brun of Louis XIV's pictures. The king certainly acquired it before 1683, and, according to Jacques Foucart, probably in 1671.

1703: The *Self-portrait* at Karlsruhe (Plate 72) was recorded in the collection of the French painter Hyacinthe Rigaud.

1705: (HdG. 585c) A *Self-portrait in Persian Dress* was in an anonymous sale in Amsterdam on 10 June 1705 as lot 30, when it made 59 florins.

1709: The *Self-portrait* of 1654 at Kassel (Plate 77) was recorded in the collection at Delft of Valerius de Reuver, who acquired in 1728 the *Self-portrait* of 1634, later also to be in the Kassel Collection.

1718: Arnold Houbraken, presumably repeating Baldinucci, noted the existence of two Rembrandt *Self-portraits* in the Uffizi, Florence (Plates 79 and 95).

1719: A *Self-portrait* closely related to the Vienna picture (Plate 78) was recorded as having been in the collection of Johann Wilhelm, Elector Palatine at Düsseldorf. It is now in the Alte Pinakothek, Munich. In spite of this early appearance the painting has never been considered to be by Rembrandt since Hofstede de Groot relegated it to the status of a copy.

THE EIGHTEENTH CENTURY

The eighteenth century was a period of rediscovery of Dutch seventeenth-century painting and many of the best painters of the middle years of the century like Nicholaes Berchem, Jan Both, Aelbert Cuyp, Jacob Ruisdael and Rembrandt himself, suddenly became popular. Many pictures changed hands with far greater rapidity than at any other time. Rembrandt's middle period was the most esteemed and his early pictures seem to have been largely ignored. His late work was on the whole much too broad for eighteenth-century taste, and would have been regarded as unfinished. By the middle of the century it is apparent that an increasing number of pictures were being attributed to Rembrandt. Their present oblivion is probably deserved.

1722: The *Self-portrait* of 1657 at Dresden (Plate 80) was listed in the Dresden inventory. The *Self-portrait* of 1669 in the National Gallery, London (Plate 96) was in the sale of William van Huls in London on 6 August 1722 as lot 22. It was bought by Thomas Brodrick, M.P., and then passed by descent into the family of the Viscount Middleton at Peper Harrow.

1724: The early *Self-portrait* in the Uffizi, Florence (Plate 22) was recorded in the collection of the Marchese Gerini.

1728: The *Self-portrait* of 1634 at Kassel (Plate 50) was in the sale of Gerard Goeree, Delft, when it was acquired for 90 florins by Valerius de Reuver.

1734: (HdG. 585d) A *Self-portrait* described as 'three quarter length, with both hands, life-size – strong and well-painted' was in an anonymous sale in Amsterdam on 17 April 1734 as lot 5, where it made 110 florins (which was still a relatively low price).

1737: The *Self-portrait* of 1632 in the Burrell Collection at Glasgow (Plate 40) was in the comtesse de la Verrue sale in Paris on 27 March as lot 14 and was sold with its pendant for 450 francs.

1741: (HdG. 585e) A *Self-portrait* was in the S. G. Uilenbroek sale in Amsterdam on 23 October 1741 as lot 10 and was bought by Bary for 120 florins.

1742: By this year the Vienna *Self-portrait* of 1652 (Plate 76) was in the Imperial Gallery there, in the collection of the Emperor Charles VI.

1748: The Duke of Bedford acquired the *Self-portrait* (Plate 66) now at Woburn Abbey, at the Bragge sale in London.

1749: All three of the Rembrandt *Self-portraits* at Kassel (Plates 10, 50 and 77) were recorded in the inventory of the landgrave Wilhelm VIII of Hesse-Kassel. The *Self-portrait* of 1634 (Plate 50) had been acquired from the collection of Madame de Reuver at Delft.

1750: (HdG. 585f, possibly identical with HdG. 525 or 566) A *Self-portrait* was in the sale of count van Wassenaar in The Hague on 19 August 1750, where it made 202 florins.

1751: The *Self-portrait with Saskia* at Dresden (Plate 59) appeared in the Araignan sale in Paris in 1751. It was acquired, then or soon after, for the Electoral Gallery at Dresden, where it has since remained.

1752: The early *Self-portrait* in the Mauritshuis, The Hague (Plate 14), one of the best in the whole of the first part of the artist's career, was recorded in the G. van Slingelandt collection, The Hague, as was the later *Self-portrait* (Plate 49), also in the Mauritshuis.

1753: The *Self-portrait with Saskia* (Plate 59) at Dresden appeared in the inventory of the Electoral picture gallery. (HdG. 585g) A *Self-portrait* described as 'strongly painted' was in an anonymous sale in The Hague on 11 December 1753 as lot 11.

1760: A *Self-portrait*, possibly that in the Wallace Collection, London (Plate 57), was in the Gerard Hoet sale in The Hague on 25 August 1760 as lot 48 and was bought by Yver for 185 florins. (HdG. 585h) A *Self-portrait* was in an anonymous sale in Amsterdam on 16 September 1760 as lot 16 and was bought by De Bruin for 75 florins.

1761: The *Self-portrait* at Kenwood, London (Plate 91) was in the comte de Vence sale in Paris on 11 February 1761, when it made 481 francs. The *Self-portrait as the Laughing Philosopher* in Cologne (Plate 98) was mentioned in *London and Its Environs Described* (Anon, London, 1761) when at Belvedere House, Erith, Kent.

1764: The *Self-portrait* of the early 1630s in Berlin (Plate 46) was recorded in the collection of Frederick the Great at Sans Souci, Potsdam. The *Self-portrait* at Karlsruhe (Plate 72) was in another sale of the comte de Vence in Paris on 9 February 1764 as lot 44. It was then in the collection of the margravine Karline-Louise, and subsequently at Karlsruhe.

1767: (HdG. 586) A *Self-portrait* described as 'half-length – life-size Almost full-face, showing one hand, on the head is a cap' appeared in the J. de Kommer sale in Amsterdam on 15 April 1767 as lot 47 and was bought by Yver for 65 florins.

1768: The early *Self-portrait* in the Mauritshuis, The Hague (Plate 14) entered the collection of the Stadhouder Willem V, as did the other *Self-portrait* now in the Mauritshuis (Plate 49), both having been in the G. van Slingelandt collection in 1752. Willem V was a collector of Old Master paintings of the highest quality, and it was partly his taste which made the Mauritshuis the great collection that it is today. The small *Self-portrait* in the Nationalmuseum, Stockholm (Plate 19) appeared in an anonymous sale in Rotterdam on 20 July 1768 as lot 26, when it made 35 florins.

1769: The *Self-portrait* at Kenwood, London (Plate 91), was recorded in the Hennessy collection, Brussels in 1771. A *Self-portrait*, possibly the picture in the Wallace Collection, London (Plate 57) was in the Baron van Vorck sale in Amsterdam on 11 May 1771 as lot 6. (HdG. 586a) A *Self-portrait* was in the sale of Sir R. Strange in London in 1771, and was bought by Lord Melbourne for £42.

1772: The oval *Self-portrait* in the Louvre (Plate 45) was in the collection of the duc de Choiseul in Paris in 1772. Hofstede de Groot noted that it may have been the *Self-portrait* acquired in London for Louis XVI on the advice of the painter Hubert Robert for 3,065 francs.

1776: The picture formerly in the Louden collection, Aerdenhout and now with Cramer, The Hague (Plate 17), was possibly the one sold in the A. Grill sale in Amsterdam on 10 April 1776, as lot 31, for 15 florins.

1778: (HdG. 586b) A *Self-portrait* was in the J. Blackwood sale in London 1778 and was bought by Le Brun, the Paris dealer, for £63.

1782: (HdG. 587) A *Self-portrait*, described as 'a soldier wearing an iron helmet and gorget, strong and well-painted' was in an anonymous sale in Amsterdam on 17 July 1782 as lot 84.

1783: (HdG. 587a) A *Self-portrait* was recorded in the collection of Prince Eugène of Savoy in Vienna. A *Portrait of Rembrandt* (?) in Indianapolis (Plate 12) was probably in the Locquet sale in Amsterdam on 22 September 1783 as lot 325 and was bought by Yver for 350 florins. It was presumably soon after in the Lubomirsky collection, Lemberg (Lvov), where it was to remain until recent years.

1786: The *Self-portrait* in Berlin (Plate 52) was recorded in the Sans Souci Palace, Potsdam, in the year of Frederick the Great's death (see the entry for 1764, for the first record of the other *Self-portrait* (Plate 46) in the king's collection).

THE FRENCH REVOLUTION AND THE NAPOLEONIC PERIOD

This was a time of great upheaval for picture collections in general and many of Rembrandt's self-portraits found their way temporarily to Paris, after being removed by the French troops from the palaces of Germany and Holland. Many more became the property of English collectors, who showed no especial interest in Rembrandt, any more than they admired Nicholaes Berchem. They tended to include Rembrandt's portraits in their collections without much comment.

1789: The *Self-portrait* of 1637 (Plate 56) was recorded in the collection of Louis XVI of France.

1790: The Washington *Self-portrait* of 1659 (Plate 88) was in the collection of George, Duke of Montague, who died that year. His daughter and heiress married the third Duke of Buccleuch, and the picture remained in the family collection throughout the nineteenth century.

1792: The *Self-portrait* in the Burrell Collection in Glasgow (Plate 40) was recorded in the Orléans Collection in Paris at the time of the transfer of that celebrated gallery to England.

1793: The *Self-portrait*, formerly at Weimar (fig. 13), was possibly in the duc de Choiseul sale in Paris in 1793, and if so made 1,100 francs.

1795: The two *Self-portraits* in the Mauritshuis, The Hague, (Plates 14 and 49) which belonged to the Stadhouder Willem V, were removed by the French troops and taken to Paris. They were returned in 1815.

1801: The *Self-portrait* in the Royal Collection at Windsor Castle (Plate 69) was possibly the picture in an anonymous sale in Amsterdam on 6 October 1801 as lot 55, which was bought by A. E. Sterck for 1,650 florins.

1806: Along with all the other paintings in the collection at Kassel, the three Rembrandt *Self-portraits* (Plate 10, 50 and 77) were removed to Paris by the Napoleonic occupying troops. They were returned to Kassel in 1815.

1810: The Duke of Portland acquired for his collection at Welbeck Abbey the *Self-portrait* which is now in the National Gallery of Victoria at Melbourne (Plate 92) and which had been previously at Bulstrode.

1811: Lord Kinnaird acquired the *Self-portrait as the Apostle Paul*, now in the Rijksmuseum, Amsterdam (Plate 94), which had been brought to England by William Buchanan in 1807.

1814: The *Self-portrait* in the Royal Collection at Windsor Castle (Plate 69) was bought by the Prince Regent, later George IV, from the Baring collection.

1815: The *Self-portrait* in the Frick Collection, New York (Plate 87), which is generally considered to be one of the best from the artist's later years, appeared on exhibition at the British Institution as being lent by the Earl of Ilchester of Melbury Park, Dorset. The pictures brought to Paris by the French troops over the preceding twenty years were returned to their respective owners under the terms of the Treaty of Vienna. Thus, no less than five Rembrandt self-portraits left Paris, two returning to The Hague (Plates 14 and 49) and three to Kassel (Plates 10, 50 and 77).

THE NINETEENTH CENTURY

The nineteenth century was a period of rapidly changing attitudes towards Rembrandt. As early as 1836, when John Smith published the first-ever catalogue of Rembrandt's paintings, some appreciation of the artist's last period is discernible (see the catalogue entries for Plates 82, 83, 90, 91 and 98 for Smith's comments). Smith was the first to produce what could be described as a scholarly art book and his approach remained the standard throughout the nineteenth century. It was only in the last decade, when Hofstede de Groot and Wilhelm von Bode attempted to bring some order into the ever-increasing confusion, that Smith became old-fashioned. There was a trend for Rembrandt's pictures to increase rapidly in price, which is in contrast to the very gradual rise in prices in the previous century.

1816: In this year the Louvre was reorganized and the experts made a valuation of the entire collection. The two oval *Self-portraits* (Plates 44 and 45) were valued at 8,000 and 10,000 francs respectively. The *Self-portrait* of 1637 (Plate 56) was also valued at 10,000 francs.

1818: The grand duke of Tuscany, Ferdinand III, acquired the early *Self-portrait* (Plate 22) for the Pitti collection. In 1931 it was transferred to the Uffizi.

1823: The *Self-portrait* formerly at Weimar (fig. 13) which belonged to John Smith was sold in Paris, to a Brussels dealer, for 4,000 francs.

1825: The *Portrait of Rembrandt*, in the City Art Gallery and Museum, Glasgow (fig. 6), now attributed to Govert Flinck, was possibly the picture in the De Beehr and van Leeuwen sale in Amsterdam on 14 November 1825 as lot 88, which was bought by Brondgeest for 400 florins.

1826: The *Self-portrait* of 1660 in the Metropolitan Museum of Art, New York (Plate 90) was in the sale of Lord Radstock in London on 12 May 1826, when it was bought by Baring for £299. 5s.

1828: The *Self-portrait* at Kenwood, London (Plate 91) was in the Danoot sale in Brussels in 1828 as lot 53 and was bought by the dealer Héris for 9,450 florins. The Vienna *Self-portrait* of 1655 (Plate 78) was in the sale of Lord Carysfort in London on 14 June 1828, where it was bought by the dealer Samuel Rogers for £69. 6s.

1830: The *Self-portrait* of 1634 in Berlin (Plate 46) was transferred from the Prussian Royal Palace to the Berlin Museum as was the other *Self-portrait* from these years (Plate 52).

1832: The Washington *Self-portrait* of 1650 (Plate 73) appeared in the sale of Sébastien Erard on 23 April 1832 as lot 119, when it made 17,100 francs.

1836: A landmark in the history of taste was made by the appearance of John Smith's *Catalogue Raisonné* (fig. 18). The purpose of this volume, which was part of a series, was to help to unmask the vast number of spurious pictures then on the art market. As a dealer, Smith was obviously cautious and

had a good eye for quality. He recorded a colossal number of pictures, most of which are still traceable and certainly knew a good two-thirds of Rembrandt's self-portraits known today. He valued the Vienna *Self-portrait* (Plate 76) at £600. The *Self-portrait* of 1660 in the Metropolitan Museum of Art, New York (Plate 90) entered the collection of Lord Ashburton, where it remained until 1907. The *Self-portrait* at Kenwood House, London (Plate 91) was acquired by the Marquess of Lansdowne.

1837: The *Self-portrait* in the Wallace Collection, London (Plate 57) was in the comte F. de Robiano sale in Brussels on 1 May 1837 as lot 544, when it made 5,000 francs.

1840: The *Self-portrait with a Dog* in the Musée du Petit Palais, Paris (Plate 37) appeared in the Schamp d'Aveschot sale in Ghent on 14 September 1840 as lot 169. It was bought by the collector Auguste Dutuit of Rouen for 15,190 francs.

1848: The *Self-portrait* in the Wallace Collection, London (Plate 57) was acquired by Lord Hertford at the Casimir Périer sale in London on 5 May 1848 for £294.
The *Self-portrait* in the Isabella Stewart Gardner Museum, Boston (Plate 20) appeared in the colossal bankruptcy sale on 15 August 1848 of the Duke of Buckingham at Stowe, which caused a sensation at the time. The painting made £54. 12s. and was bought by Lord Ward.

1849: The *Self-portrait* of 1650 in Washington (Plate 73) appeared in the Hope sale in London on 14 June 1849, when it was bought by Baron Rothschild for £483.

1850: The *Self-portrait* formerly at Weimar (fig. 13) appeared at the sale of the important collection of King Willem II of Holland in The Hague on 12 August 1850 as lot 87. It was bought by the dealer Nieuwenhuys for 3,750 florins.

1851: Sir Charles Eastlake acquired for the National Gallery, London, the *Self-portrait* of 1669 (Plate 96), now thought to be one of the last the artist painted, at the sale of the fifth Viscount Middleton in London on 31 July 1851 as lot 78, for £430. 10s.

1855/6: Archibald McLellan's vast collection of pictures was bought by the Corporation of Glasgow, including the *Portrait of Rembrandt* (fig. 6), now thought to be by Govert Flinck.

1856: The Vienna *Self-portrait* of 1655 (Plate 78)was in the Samuel Rogers sale, London, when it made £325. 10s., a large increase from its previous price in 1828.

1857: The Manchester Art Treasures exhibition, which is still arguably the greatest exhibition of Old Master paintings ever held, included the *Self-portrait* now in the Isabella Stewart Gardner Museum, Boston (Plate 20), which had been in the Duke of Buckingham's collection at Stowe, and the *Self-portrait* in the Royal Collection at Windsor Castle (Plate 69). The picture formerly in the Louden Collection, Aerdenhout (Plate 17) and now with Cramer, The Hague, was stated by Hofstede de Groot to have been sold in London 'about the year 1857' and then to have been in the collection of Count Julius Andrassy, Budapest.

1860: The *Portrait of Rembrandt* (fig. 16) attributed to Carel Fabritius, but formerly thought to be a Rembrandt *Self-portrait* and catalogued as such by Hofstede de Groot, was presented to the town of Leipzig with an attribution to the German painter Christian Wilhelm Ernst Dietrich (1712-74). The *Self-portrait (as the Laughing Philosopher)* (Plate 98) in Cologne appeared at the sale of Sir Culling E. Eardley in London on 30 June 1860.

1861: Sir Charles Eastlake bought for the National Gallery, London, the famous *Self-portrait* of 1640 (Plate 65) from the de Richemont family of Paris, for the relatively small sum of £800.

1863: The Vienna *Self-portrait* of 1655 (Plate 78) was in the Evans-Lombe sale in Paris on 27 April 1863, when it made 6,800 francs.
The J. B. M. Bourguignon de Fabrigoules collection was be-

queathed by his son to the Musée Granet at Aix-en-Provence. It contained the small *Self-portrait* (Plate 84) whose previous history is unfortunately unknown.

1876: The publication of *Les Maîtres d'Autrefois* by the painter and critic Eugène Fromentin marks a new departure in art criticism. His work is still amongst the most sensitive ever written on Dutch painting, but Fromentin only knew the self-portraits in the Louvre, as none of the other picture galleries familiar to him contained self-portraits by Rembrandt. Fromentin was interested in the emotions of the painter, as much as in the quality of the paint itself (see catalogue entries for Plates 45 and 89 for Fromentin's comments).

1879: The *Self-portrait* in the Norton Simon Gallery, Pasadena (Plate 64) appeared in the sale of the Earl of Portarlington in London on 28 June 1879, when it made £1,312. 10s.

1881: The *Self-portrait (as the Laughing Philosopher)* in Cologne (Plate 98) appeared at the sale of Leopold Double in Paris on 30 May 1881 as lot 19, when it made 21,150 francs.

1884: The *Self-portrait* in the Norton Simon Gallery, Pasadena (Plate 64) reappeared in the saleroom after only five years as from the collection of Albert Levy of London on 3 May 1884. Its price had risen to £1,890. Soon afterwards it entered the Heywood Lonsdale collection of Shavington Hall, Shropshire.

1893: Emile Michel's vast and well-illustrated biography on the whole of Rembrandt's art was published. His insights were perceptive and his attitudes form a useful record of how Rembrandt was seen at the end of the nineteenth century. There was still a reluctance to include many of the late self-portraits.

1895/8: The Paris dealer Sedelmeyer, who handled an enormous number of Old Master paintings in the late nineteenth century, had the *Self-portrait* in Sao Paulo (Plate 58), which had come from Lord Palmerston's collection at Broadlands, Hampshire, and also the Vienna *Self-portrait* of 1655 (Plate 78).

1899: The *Self-portrait* of 1669 in the Mauritshuis, The Hague (Plate 97), now generally accepted as Rembrandt's last surviving self-portrait, made its first appearance when it was exhibited at the Royal Academy, London, as from the collection of Sir Audley Neeld, Bt, of Grittleton House, Wiltshire.

THE TWENTIETH CENTURY

In the twentieth century the attitude towards Rembrandt in general, and the self-portraits in particular, has been ambivalent. Almost all his best self-portraits were bought by, or given to, collections and the art market therefore lost its significance as a barometer of taste. The most important change of attitude which it is possible to chart is the increasing preoccupation with authenticity at the expense of critical appreciation. The most recent trend has been the largely haphazard application of scientific analysis to individual pictures or groups which are in the same collection. Most of the results of such enquiries are in the hands of bureaucrats or are subject to the interpretation of journalists, with calamitous consequences. An exception is the exemplary study of all the pictures by and attributed to Rembrandt in the Mauritshuis, The Hague (see bibliography).

1902: The *Self-portrait with a Dog* (Plate 37) formed part of the enormous bequests of Auguste Dutuit to the Musée du Petit Palais, Paris.

1906: The *Self-portrait* in Sao Paulo (Plate 58) was in the Baron von Konigswater sale in Berlin on 26 November 1906 as lot 72 when it made the colossal sum of 180,000 marks. It was bought by the dealer Gutmann of Vienna.

1907: The New York *Self-portrait* of 1660 (Plate 90) was sold along with the rest of the collection of Lord Ashburton. It was acquired soon after by Benjamin Altman of New York.

1908: Henry Clay Frick acquired the now celebrated *Self-portrait* (Plate 87) from the dealer Knoedler.

1909: Several self-portraits by Rembrandt were included in the Hudson-Fulton Celebration at the Metropolitan Museum of Art, New York. Included were the following: The *Self-portrait* in the Metropolitan Museum of Art, New York (Plate 90), the *Self-portrait* in the Thyssen collection at Lugano (Plate 68), the *Self-portrait* of 1650 in Washington (Plate 73) and the *Self-portrait* (Plate 87) from the Frick Collection, New York.

1913: Benjamin Altman bequeathed, along with many other pictures of the highest quality, the *Self-portrait* of 1660 to the Metropolitan Museum of Art, New York (Plate 90).

1916: The Liverpool *Self-portrait* (Plate 21) was recorded by Hofstede de Groot as being with Colnaghi, London.

1921: The *Self-portrait* (fig. 13) was stolen from the Weimar Museum. It later reappeared in Washington when it was exhibited at the National Gallery. Its present whereabouts do not seem to be known and its status is problematic.

1922: The *Self-portrait* in San Francisco (Plate 81) was sold from the collection at Temple Newsam House, Leeds, as a copy. Its subsequent publication as an original has not stood the test of later criticism and those who have seen it, including the present writer, admit that the Dresden version (Plate 80) is superior.

1926: The Earl of Iveagh gave the *Self-portrait* (Plate 91) at Kenwood House, along with a small but choice collection of Dutch and English pictures, to the then London County Council. The Earl of Iveagh had acquired it from the Lansdowne collection through Agnew in 1888.

1933: The National Gallery of Victoria, Melbourne, acquired the *Self-portrait* (Plate 92), on the advice of Randall Davies, from the collection of the Duke of Portland at Welbeck Abbey, where it had been since 1810. Previously the inferior version at Newbattle Abbey had been considered to be the original.

1936: Abraham Bredius's book on Rembrandt made its appearance. Although people no longer agree with Bredius in detail, the general principles he established for Rembrandt's art are still adhered to. Modern criticism would accuse him of being far too generous with his attributions now, although at the time he appeared very severe, reducing the corpus very considerably from the impossible proportions constructed by Valentiner. The *Self-portrait (as the Laughing Philosopher)* (Plate 98) formed part of the von Carstanjen Bequest to the Wallraf – Richartz Museum, Cologne. Hitherto the picture had been little known.

1937: The National Gallery of Art in Washington was founded. The *Self-portrait* of 1650 (Plate 73) came from the Widener collection and the *Self-portrait* of 1659 (Plate 88) came from the Mellon Collection as part of the Foundation gifts.

1939: The other version of the *Self-portrait* at Woburn Abbey (Plate 66) was acquired by the National Gallery of Canada at Ottawa (Plate 67). It had been in the collection of the Earls of Listowel. There is still no critical agreement as to which is the better version.

1946: Sir William Burrell acquired the *Self-portrait* of 1632 (Plate 40) at the sale of Viscount Rothermere and added it to his already vast collection, which was subsequently given to the city of Glasgow.

1947: The Mauritshuis, The Hague, bought the *Self-portrait* of 1669 (Plate 97) thus making it the only collection to have three self-portraits from different periods in the artist's career.

1948: The appearance of the first edition of Jacob Rosenberg's study of *Rembrandt: Life and Work*, which devoted a thorough and sensitive chapter to the self-portraits.

1952: The early *Self-portrait* (Plate 18) was bequeathed to the Metropolitan Museum of Art, New York by Evander B. Schley; it is now considered by the museum to be later than Rembrandt's lifetime.

1953: The Alte Pinakothek in Munich acquired the *Self-portrait* (Plate 8) from the family collection of the dukes of Saxe-Coburg-Gotha, and the Walker Art Gallery, Liverpool, was given by the Holt Trustees the early *Self-portrait* (Plate 21) which answers the description of the picture which belonged to King Charles I of England (see the entry for 1633).

1956: The *Self-portrait as the Apostle Paul* (Plate 94) was presented to the Rijksmuseum, Amsterdam by Mr and Mrs I. de Bruijn-van der Leeuw. It had formerly been in the collection of Lord Kinnaird.

1958: The Rijksmuseum, Amsterdam acquired from the B. Katz Gallery, Dieren, the *Self-portrait* (?) (Plate 13) from the Leiden period.

1969: The revision of Abraham Bredius's work of 1936 by Horst Gerson was published. It caused a sensation at the time because so many pictures accepted by Bredius were doubtful. The self-portraits suffered particularly badly; at least twenty

of them were doubted (12, 15, 16, 18, 37, 39, 50, 51, 56, 58, 66, 67, 73, 77, 79, 81, 84, 92, 93 and fig. 13).

1977: The Rijksmuseum, Amsterdam, acquired the *Self-portrait* (Plate 11) on loan from a private collection.

1981: A number of pictures have changed hands, notably the *Self-portrait* (Plate 68) formerly in the collection of Duke Eugen von Leuchtenberg, St. Petersburg, and later lent to the Boston Museum of Fine Arts. It has now been acquired by the Thyssen collection, Lugano. The early *Self-portrait* (Plate 17) long in the Louden collection at Aerdenhout is with Cramer, The Hague, and the *Self-portrait* (Plate 15) formerly in the Berens collection, London, was acquired by a New York private collection.

Rembrandt studies are at present in the hands of a committee and the results of their work are beginning to be revealed in the press. If the present trend continues the number of pictures considered to be by Rembrandt will diminish still further. This is probably quite reasonable in general terms since there are still too many pictures, in public collections alone, for one man to have painted.

SELECT BIBLIOGRAPHY

The literature devoted specifically to Rembrandt's self-portraits is remarkably sparse considering the vastness of the Rembrandt literature as a whole. The best appraisal is the relevant chapter in Jacob Rosenberg: *Rembrandt: Life and Work* Cambridge, Massachusetts (first edition, 1948). The following annotated list is limited to a selection of the most useful catalogues. The earliest is in many ways the most interesting because Smith allowed himself the occasional comment on quality. The difficulty with modern Rembrandt scholarship is that it is often impossible to discover the level of esteem in which a particular picture is held, so great is the preoccupation with authenticity, scientific analysis and iconography. John Smith's *A Catalogue Raisonné of the Works of the Most Eminent Dutch, Flemish and French Painters*, vol. VII: *Rembrandt* (London 1836), [Abbreviation: Smith] which was probably the first ever book on Rembrandt, had an engraving of the Edinburgh *Self-portrait* (Plate 82) as a frontispiece (fig. 18).

Fifty years passed before Wilhelm von Bode and Cornelis Hofstede de Groot's *Rembrandt: beschreibendes Verzeichnis Gemälde mit den heliographischen Nachbildungen* (Paris, 1897-1906), [Abbreviation: Bode and HdG] a beautifully produced set of volumes by the two most eminent scholars of the day, set the standard for future catalogues until Bredius in 1935. Von Bode and de Groot's work was followed by W. R. Valentiner's *Klassiker der Kunst: Rembrandt des Meisters Gemälde* (Stuttgart and Leipzig, 1909), [Abbreviation: Valentiner] which was part of a series of illustrated books on the Old Masters. This very successful book ran through several editions and a *Supplement* was issued in 1921. Valentiner tended to be over-generous with his attributions, but the illustrations form a useful record of pictures which can no longer be traced. Cornelis Hofstede de Groot's *A Catalogue*

Raisonné of the Work of the Most Eminent Dutch Painters of the Seventeenth Century, Based on the Work of John Smith. Rembrandt, Nicolaes Maes (Stuttgart, 1915; English edition, London 1916), [Abbreviation: HdG] took up the methods established by Smith, but his work was much more detailed and included many new pictures. Abraham Bredius's *The Paintings of Rembrandt* (Vienna, 1936; English edition, London, 1937), [Abbreviation: Bredius] was the first example of twentieth-century connoisseurship, based on the strong personal opinion of the compiler. This catalogue was largely based on the work of Hofstede de Groot with the notes on the pictures compiled by Horst Gerson. Modern scholarship is represented by Kurt Bauch's *Rembrandt Gemälde* (Berlin, 1966), [Abbreviation: Bauch] a carefully compiled book by a respected scholar. The author's cautious approach has not received the attention it deserves. The only study devoted specifically to Rembrandt's self-portraits is Fritz Erpel's *Die Selbstbildnisse Rembrandts* (first edition Vienna/Munich, 1967) [Abbreviation: Erpel]. Gerson wrote a highly personal *Rembrandt* (Amsterdam, 1968) [Abbreviation: Gerson] from which he omitted many of the problematic pictures. His survey is well-balanced and is standing the test of time. Gerson's revision of Bredius's *Rembrandt Paintings* (London, 1969) [Abbreviation: Bredius/Gerson], is a carefully thought out, if controversial, revision of Bredius's work of 1936. Gerson's new notes are succinct and well done even if his opinion appears extreme. Almost all existing opinion is well-discussed in Giovanni Arpino and Paolo Lecaldano's: *L'opera pittorica completa di Rembrandt* (Milan, 1969) [Abbreviation: Opera Completa], a summary incorporating Gerson's observations and useful reproductions of many doubtful and problematic pictures.

The first volume of the findings of the Rembrandt committee is now awaited and their findings will change the accepted Rembrandt corpus more than any previous authority.

Cat. No.	Plate No.	Location	Smith (1836)	Bode and HdG. (1897-1906)	Valentiner (1909) page	HdG. (1916)
1	[8]	Munich	470	13	27	542
2	[10]	Kassel	—	11	27	533
3	[11]	Amsterdam	—	—	—	—
4	[12]	Indianapolis	—	646	29	549
5	[13]	Amsterdam	—	15	30	531
6	[14]	The Hague	243	16	32	544
7	[15]	New York	—	547	31	552
8	[16]	Cambridge, Mass	—	—	—	—
9	[17]	The Hague	—	17	32	538
10	[18]	New York	—	—	—	564
11	[19]	Stockholm	—	549	28	570
12	[20]	Boston	422(?)	18	31	529
13	[21]	Liverpool	—	—	—	552A
14	[22]	Florence	235 345 367 414	170	148	538
15	[37]	Paris	321 Supp. 26	550	54	350
16	[38]	Switzerland	229	—	—	under no. 350
17	[39]	Eindhoven	442 236 240	—	—	486
18	[40]	Glasgow	272	61	39	573
19	[44]	Paris	347	163	144	566
20	[45]	Paris	199 253	164	143	567
21	[46]	Berlin	378	167	frontis	526
22	[49]	The Hague	245	165	146	545
23	[50]	Kassel	375	169	148	534
24	[51]	Formerly Vaduz	—	174	150	584
25	[52]	Berlin	228	168	144	525
26	[56]	Paris	217	176	150	558
27	[57]	London	—	171	149	559
28	[58]	Sao Paulo	231 241 419	172	142	582
29	[59]	Dresden	163	157	133	334
30	[63]	Dresden	171	238	229	283
31	[64]	Los Angeles	—	175	241	576
32	[65]	London	—	256	242	550
33	[66]	Woburn Abbey	214	255	245	585
34	[67]	Ottawa	—	—	—	—
35	[68]	Lugano	—	260	316	565
36	[69]	Windsor	200	261	317	555
37	[72]	Karlsruhe	—	258	317	547
38	[73]	Washington	211	346	319	574
39	[76]	Vienna	223	424	399	580
40	[77]	Kassel	227	349	396	536
41	[78]	Vienna	212	426	397	528
42	[79]	Florence	—	425	398	539
43	[80]	Dresden	203	427	398	537
44	[81]	San Francisco	—	—	—	copy of Dresden
45	[82]	Edinburgh	204	430	401	553
46	[83]	Vienna	222	506	478	581
47	[87]	New York	225	428	400	563
48	[88]	Washington	215 and supp. 28	431	403	554
49	[89]	Paris	219	434	405	569
50	[90]	New York	210	429	411	562
51	[91]	London	207	503	477	556
52	[92]	Melbourne	—	502 (Newbattle Abbey copy)	476 (Newbattle Abbey copy)	579
53	[93]	Cambridge, Mass	—	—	—	—
54	[84]	Aix-en-Provence	—	432	404	524
55	[94]	Amsterdam	209 230 432(?)	501	475	575
56	[95]	Florence	218	504	478	540
57	[96]	London	—	433	402	551
58	[97]	The Hague	—	507	479	527
59	[98]	Cologne	220	506	479	560

ON THE PAINTINGS

Bredius (1936)	Bauch (1966)	Erpel (1967)	Gerson (1968)	Opera Completa (1969)	Bredius/Gerson (1969) *page*	Cat. No.
2	290	10	32	27	2	1
1	288	9	30	8	1	2
—	287	8	—	attr.	— version of Kassel	3
3	289	6	—	attr.	3 (Lievens prototype suggested)	4
5	298	27	33	37	5	5
6	295	15	39	29	6	6
7	294	17	40	28	7 wiser not to offer final comments	7
4	291	12	—	attr.	4 not fully convinced of attr.	8
9	300	32	45	39	8	9
10	293	13	—	31	9 not convinced of attr.	10
11	299	34	44	38	9	11
8	292	18	38	30	8	12
12	297	35	41	26	10	13
20	306	49	144	152	16 difficult to judge	14
16	301	42	—	attr.	12 as probably by a Leiden follower	15
—	—	—	—	—	—	16
13	296	37	—	attr.	11 neither by Rembrandt nor from his period	17
17	302	43	99	79	13	18
18	303	51	129	112	14	19
19	305	52	142	153	15	20
21	308	53	158	154	17	21
24	311	62	189	206	20	22
22	307	54	157	155	18 Govert Flinck?	23
25	309	56	171	164	21 close to Flinck	24
23	304	50	133	156	19	25
29	310	65	—	attr.	24 Flinck	26
27	315	66	237	232	23	27
26	172	127 doubtful	188	187	22 not wholly convincing	28
30	535	57	79	165	25-26	29
31	312	71	191	217	27	30
32	313	70	229	207	28	31
34	316	74	238	233	29	32
33	—	72b	—	copy of 218?	32 too weak to be an original	33
—	314	72a	236	218	no comment	34
36	317	75	240	248	31 attribution both to Rembrandt and to the seventeenth century doubted	35
37	319	77	253	247	33	36
38	320	79	262	attr.	34	37
39	321	82	—	attr.	35 eighteenth or nineteenth century imitation	38
42	322	85	308	314	38	39
43	324	87	310	321	39 not wholly convincing	40
44	325	89	320	333	40	41
45	328	88	399	365	42 difficult to judge, but probably a copy	42
46	—	86c	—	attr.	42 best version	43
47	—	86b	—	attr.	43 unimpressive	44
48	327	90	45	363	41	45
49	326	91	324	364	44	46
50	329	93	343	366	45-46	47
51	330	95	376	378	47	48
53	333	98	389	380	49	49
54	332	99	381	381	50	50
52	331	96	380	379	48, 56	51
56	335	101	—	attr.	50 photographs do not give a favourable impression	52
57	334	100	—	attr.	51 attr. uncertain	53
58	336	102	—	attr.	51 imitator	54
59	338	105	403	405	52	55
60	340	107	—	430	53	56
55	339	108	415	449	55, 57	57
62	342	109	420	450	58	58
61	341	106	419	436	54	59

INDEX